WICKED WEATHER

A Visual Essay of Extreme Storms

WARREN FAIDLEY

AMHERST MEDIA INC ■ BUFFALO NY

Published by:
Amherst Media, Inc.
PO BOX 538
Buffalo, NY 14213
www.AmherstMedia.com

Publisher: Craig Alesse
Senior Editor/Production Manager: Michelle Perkins
Editors: Barbara A. Lynch-Johnt, Beth Alesse
Acquisitions Editor: Harvey Goldstein
Associate Publisher: Katie Kiss
Editorial Assistance from: Carey A. Miller, Roy Bakos, Jen Sexton-Riley, Rebecca Rudell
Business Manager: Sarah Loder
Marketing Associate: Tonya Flickinger

ISBN-13: 978-1-68203-346-3
Library of Congress Control Number: 2017963178
Printed in the United States of America
10 9 8 7 6 5 4 3 2 1

AUTHOR A BOOK WITH AMHERST MEDIA!

Are you an accomplished photographer with devoted fans? Consider authoring a book with us and share your quality images and wisdom with your fans. It's a great way to build your business and brand through a high-quality, full-color printed book sold worldwide. Our experienced team makes it easy and rewarding for each book sold—no cost to you. E-mail submissions@amherstmedia.com today!

www.facebook.com/AmherstMediaInc
www.youtube.com/AmherstMedia
www.twitter.com/AmherstMedia

CONTENTS

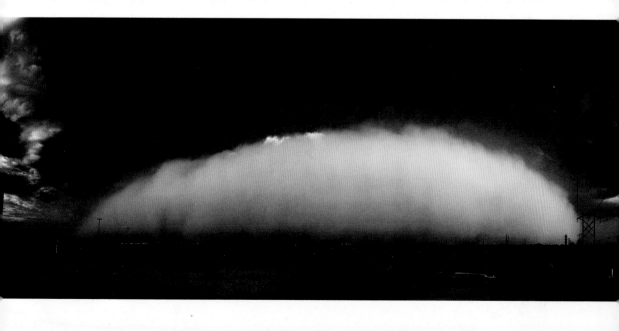

About the Author

Warren Faidley is an extreme weather photojournalist, adventurer, and natural disaster survival expert.

He is the first person to pursue storms and natural disasters as a full-time occupation. Over the course of the last 30 years, his hands-on experiences of outwitting dangerous situations has made him one of the world's most sought-after experts on storm-and-disaster survival.

His work has appeared on television shows and in hundreds of newspapers, advertisements, and magazines, including *National Geographic*, CNN, Fox News, The Weather Channel, and the Discovery Channel. His image of a tornado near Miami, TX, was used as promotional cover art for the motion picture *Twister*.

Warren's interest in violent weather and adventure began at age 12, when he nearly lost his life after being carried away by a flash flood. In 1988, he photographed a lightning bolt hitting a light pole less than 400 feet away from him. *Life* magazine published the image in 1989 and his career was launched. He formed the stock photography company Weatherstock Inc. in 1997, which became the world's largest library of high-quality weather and storm images and footage.

Warren is based out of Tucson, AZ. He graduated from the University of Arizona in 1989. He is a pilot, ex-wildland firefighter, tactical EMT, and historical fencing instructor. He has won numerous awards and citations for his work and charitable contributions.

Dedication

This book is dedicated to the storm chasers, scientists, and spotters who have lost their lives while pursuing extreme weather.

I would also like to mention the following people: "Cyclone" Jim Leonard (1950–2014), an inspirational chaser who pursued tropical cyclones around the world. Phil Henry (1940–2015), one of my original chase team members, and Argyll Amparan, my best friend and fellow adventurer who passed away in 2015.

A special thank you goes out to my current adventure associates, Randy, Jason, and Cary.

A loving dedication goes out to my wonderful wife Heather, who has supported me without complaint, despite my often Indiana Jones-like lifestyle.

INTRODUCTION

For the past 30 years, I have forecast, intercepted, and photographed some of the planet's most extreme weather and natural disasters.

As a photojournalist, natural disaster survival expert, and adventurer, my expeditions have covered countless miles. Along the way, I have witnessed both the dark side and breathtaking beauty of Mother Nature's mysterious ways.

I have journeyed into the heart of darkness as hurricanes Andrew and Katrina brought rage and ruin to thousands. Tornadoes, firestorms, earthquakes, and lightning bolts are forever recorded by my cameras, but my memories are filled with the human elements of hope and survival.

My obsession is driven by a quest to find the perfect image in the midst of total chaos. It's a physical and mental challenge, but more enticing, it's a never-ending treasure hunt, as I never know what I'll encounter.

Such unpredictability comes in many forms. The roar of an EF5 tornado, dodging grapefruit-size hailstones, fighting off a spider colony with the leg of a tripod, fire ants, sinkholes, and even angry farmers yielding rusty pitchforks when parked too close to their property.

The sum of it all is to be there—at the right place at the right time. It's a massive chess game of risk and reward played out over endless horizons, as I capture visions that would have otherwise been lost forever.

I am a traveler and explorer. My images tell the story.

—Warren Faidley

LIGHTNING

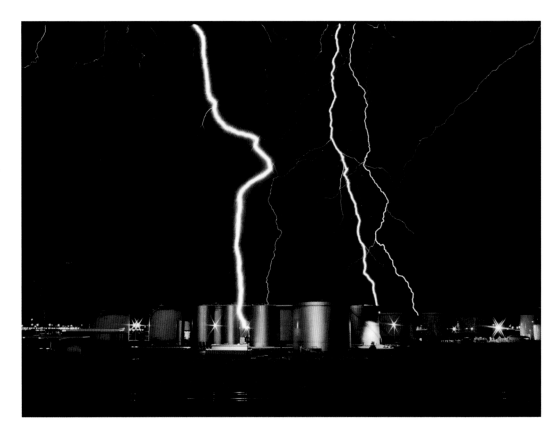

The Start of a Career

This lightning photograph launched my career as an extreme weather photojournalist.

Shot in Tucson, AZ, on October 16, 1988, the picture was the result of fighting off an angry colony of black widow spiders and a secondary lightning strike that nearly fried me.

Captured from a mere 400 feet away, the picture remains the closest lightning strike ever captured on a medium format-sized transparency.

In 1989, *Life* magazine published the image and billed me as a "Storm Chaser." Overnight, I began receiving requests from around the world for interviews and storm images. The demand never stopped.

The Art of Visualization

This is one of my favorite lightning shots.

Many lightning pictures are accomplished after years of visualizing specific shots. I had imagined this type of thunderhead set against a sunset for years, until one lucky night when it all came together at the right time and place. As someone once said, "Luck is the residue of design." Seen from "A" Mountain in Tucson, AZ.

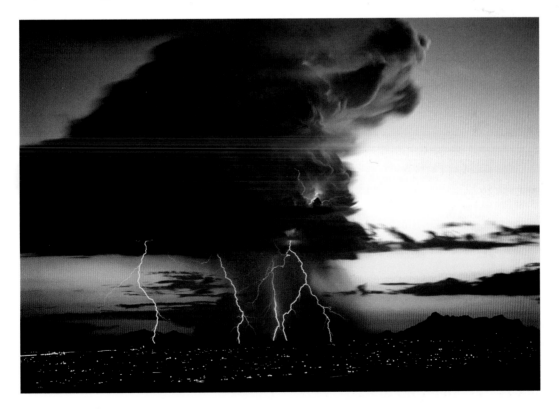

The Early Days

(above) The early days of my photojournalism career. I started out shooting fires and disasters. I then sold the front-page images to competing newspapers until one finally gave in and hired me. My initial journalism work taught me to work under extreme conditions while staying out of trouble . . . most of the time!

The Foothills

(following page) Lightning bolts strike the foothills south of Tuscon, AZ.

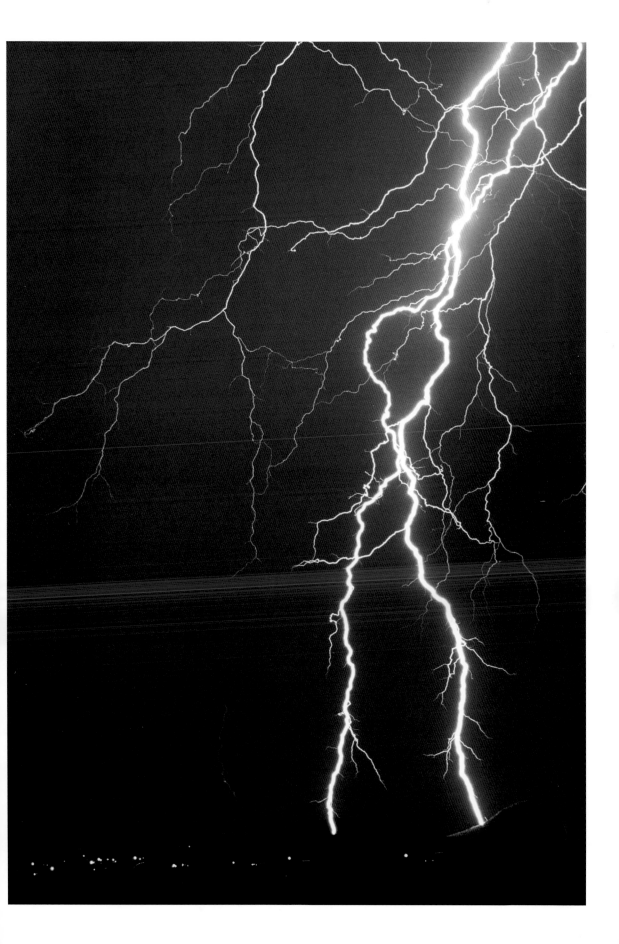

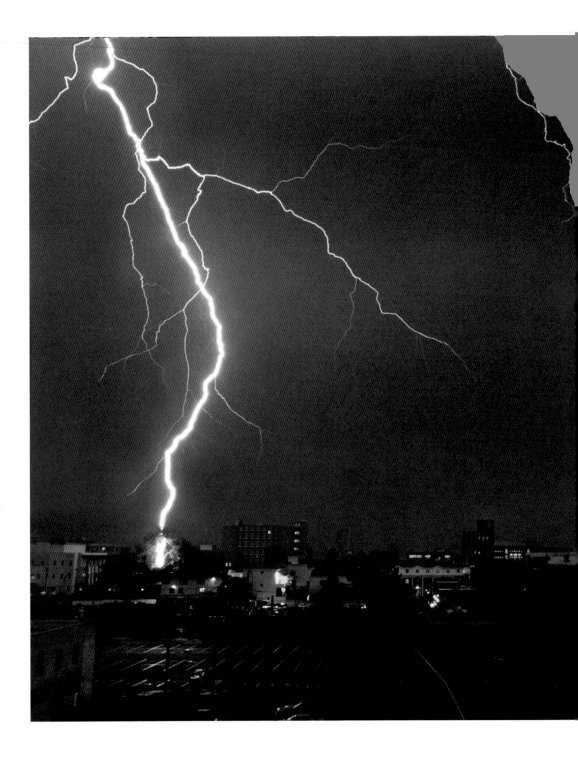

A Dangerous Pursuit

The unpredictable nature of lightning makes for a challenging and often dangerous pursuit. This unexpected bolt hit a tree less than a mile away from my camera on the University of Arizona Campus, Tucson.

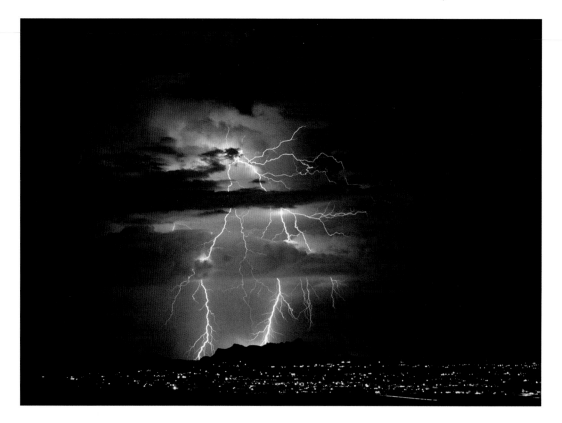

Nature's Lightbulb

(above) Thunderheads are my favorite lightning storms to photograph. The internal flashes often illuminate the clouds like a lightbulb, providing depth and contrasting colors. Most of the lightning shots seen in this book were shot on film. While I was taking this image in Tucson, AZ, a fellow photographer shooting next to me got so excited he accidentally kicked his tripod, nearly ruining his shot.

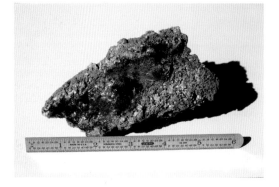

Fulgurite

(left) Lightning can generate extreme temperatures of over 50,000°F, while the surface of the sun is a much cooler 10,000°F. When a lightning bolt hits the ground, it can sometimes fuse sand and dirt into a hard rock material known as a "fulgurite," like this one from southeast AZ.

Secret to Success

My formula for shooting lightning is very simple: Don't get killed and don't step on anything that can bite back. Over the years, I've encountered spiders, rattlesnakes, killer bees, and stray gunfire.

My exposures are always based on existing light. I measure the light and set the exposure. I always try for the longest exposure possible to increase the odds of capturing a discharge. My f-stops are almost always f/4.5 or f/5.6, as closing the shutter too much makes the lightning bolts look thin. The good thing about digital cameras (as opposed to old film cameras) is that you can instantly test and review exposures. I often wonder how many pictures I missed while fiddling with film cameras.

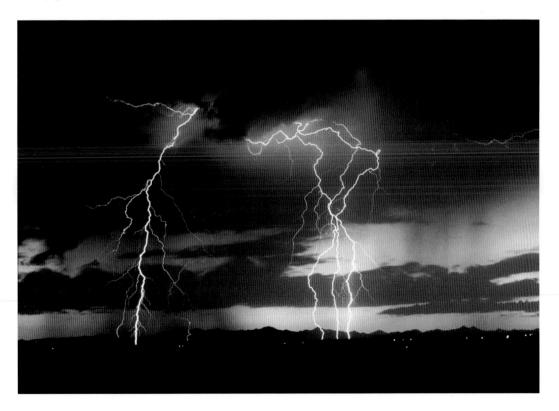

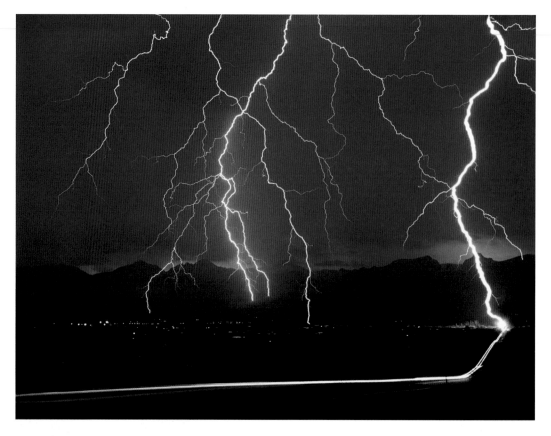

Color and Depth

(above) Unlike the flat landscapes of the Plains and Florida, the mountainous landscapes of the southwestern U.S. provide excellent backdrops for lightning photography. Without the mountains, this image shot near Tucson, AZ, would be much less dramatic.

Close to Home

(following page) Sometimes you don't need to travel far to end up with a great image. I shot this nearby lightning bolt hitting a tree behind my home in Tucson from the "semi-safety" of an upstairs bedroom with a cool drink in my hand.

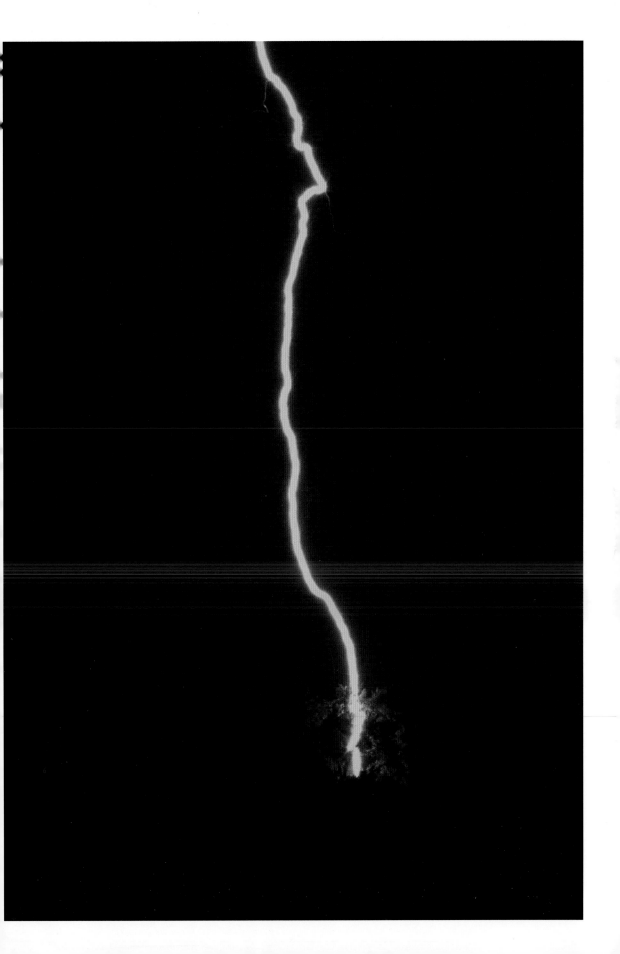

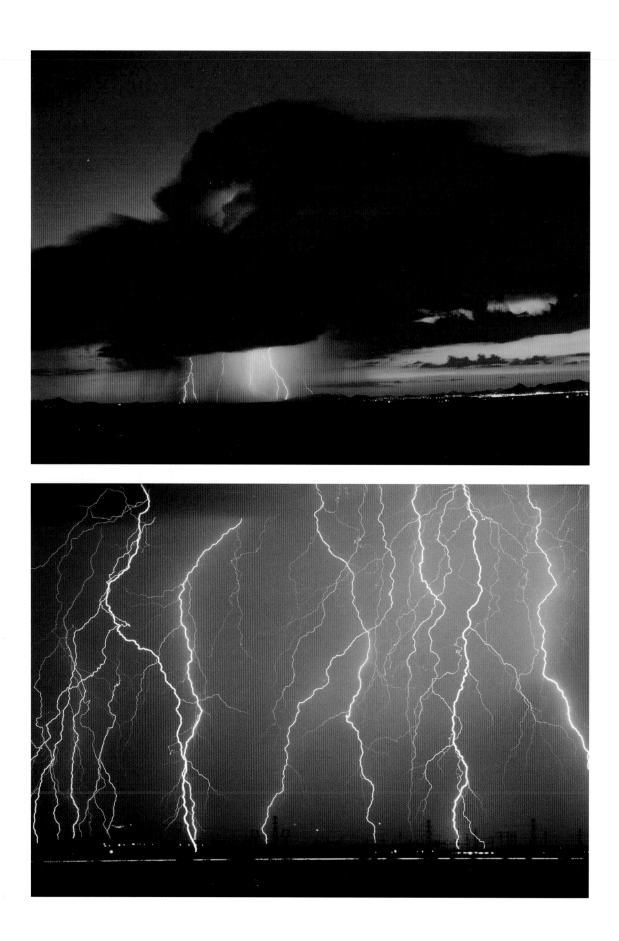

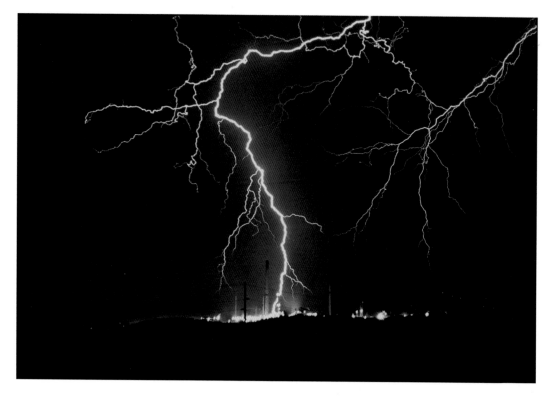

Sunset and Ash

(previous page, top) The blood-red backdrop for this thunderhead in Tucson was provided in part by a sunset enhanced by volcanic ash from the Mt. Pinatubo eruption in 1991. I rarely use filters for lightning photography.

Attraction

(previous page, bottom) Power grids attract two things: lightning bolts and Godzilla. This long exposure of greater than 2 minutes captured a very active monsoon storm that produced several hundred lightning strikes. Southeast Arizona.

Shocking!

(above) Workers at this copper smelter near Mammoth, AZ, were undoubtedly startled when a very powerful lighting bolt struck the plant in the middle of the night. The first lightning strike of a thunderstorm is often the most dangerous, as people are not always expecting it.

TORNADOES
and LAND STORMS

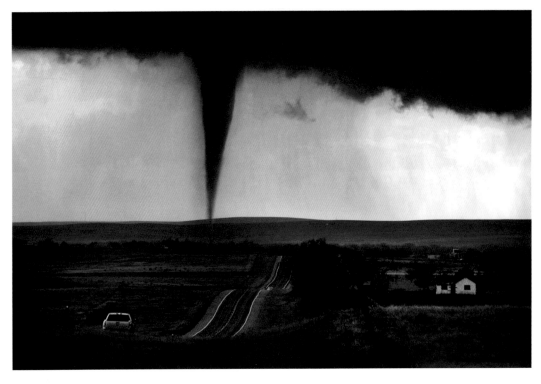

Simla, Colorado

(above) A tornado passes near Simla, CO, in June of 2015. Although this tornado was more picturesque than destructive, powerful tornadoes can produce extreme damage, with winds of over 300mph.

Cumulonimbus Clouds

(following page) Cumulonimbus clouds exploding near Laverne, OK, in May of 1991. This storm eventually produced a large tornado.

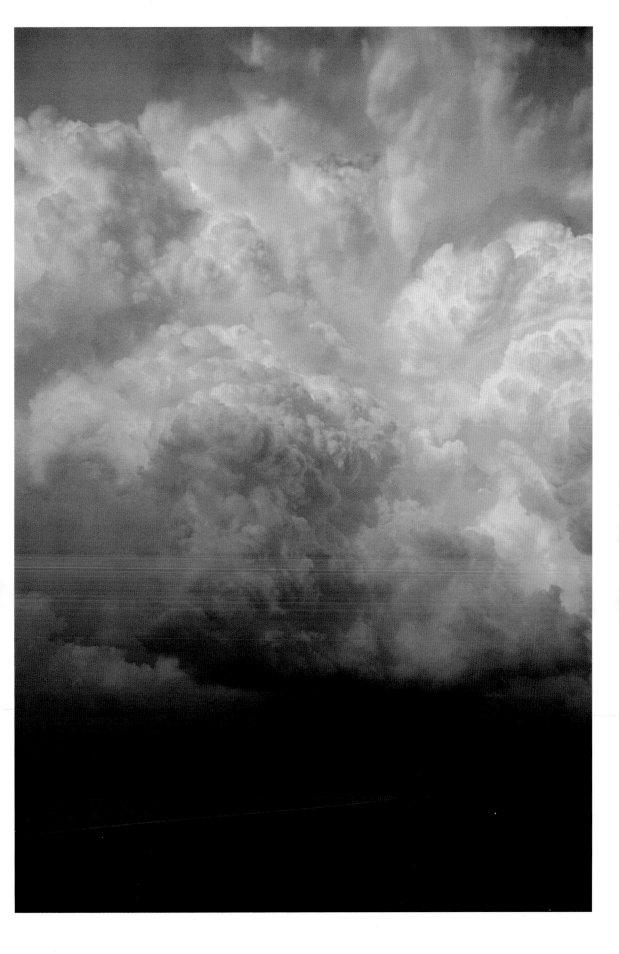

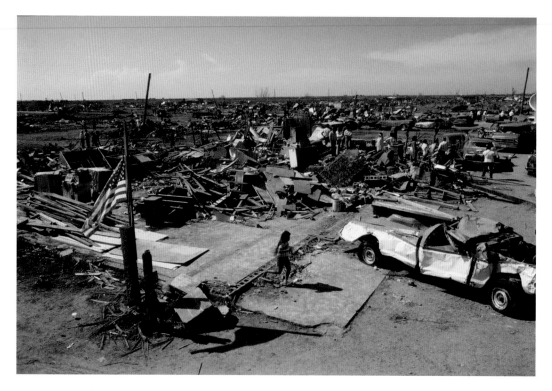

An F4 Tornado

My first venture into Tornado Alley on May 22, 1987 took me by happenstance to the small farming community of Saragosa, TX, where an F4 tornado destroyed almost the entire town, killing some 30 people. As a young photojournalist, this tragedy would teach me to respect the awesome and sometimes deadly nature of my pursuits.

Escape

A woman survived the Saragosa tornado by taking shelter in a broom closet. It was the only part of her home not leveled by the tornado. This fork, impaled into a completely debarked tree trunk, came from her kitchen.

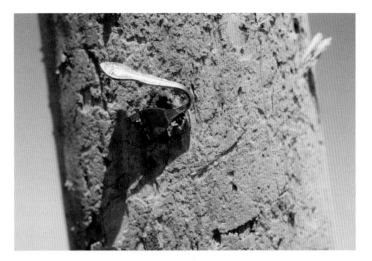

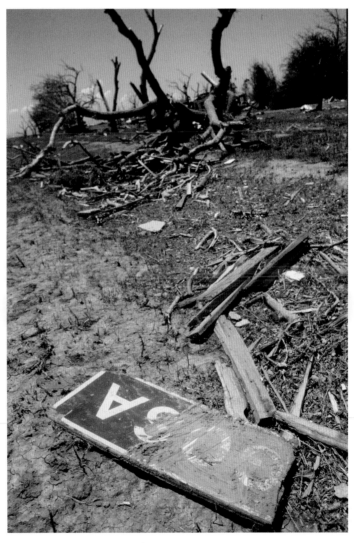

Bad Sign

Saragosa's highway sign split in half by the tornado. I could not find the other half.

Extended Vortex

An unusually long tornado captured near McLean, TX, in June of 1997. This picture is a good reminder that tornadoes can form and strike from various locations around a storm.

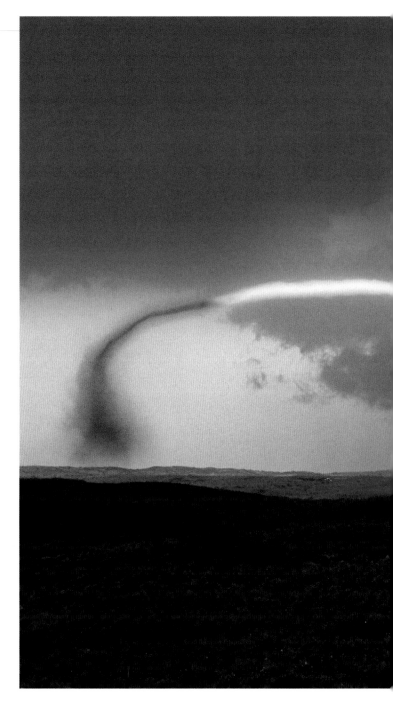

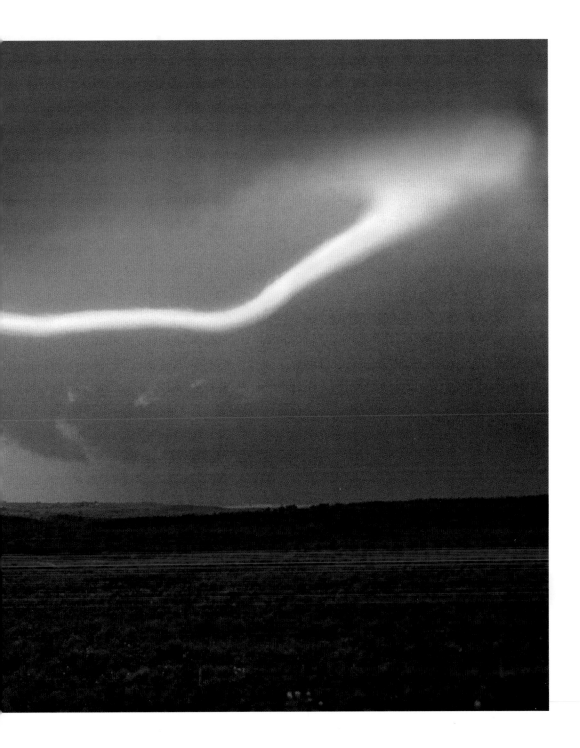

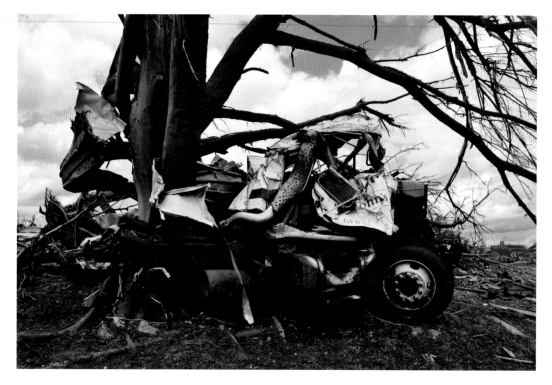

Joplin, Missouri

(above) One of the most extreme damage images I have ever taken. This semi truck's steel frame was wrapped around a large tree trunk as an EF5 tornado struck Joplin, MO, on May 22, 2011. The violent tornado killed over 155 people.

Last Supper

(following page) Some pictures don't need a caption. Joplin, MO.

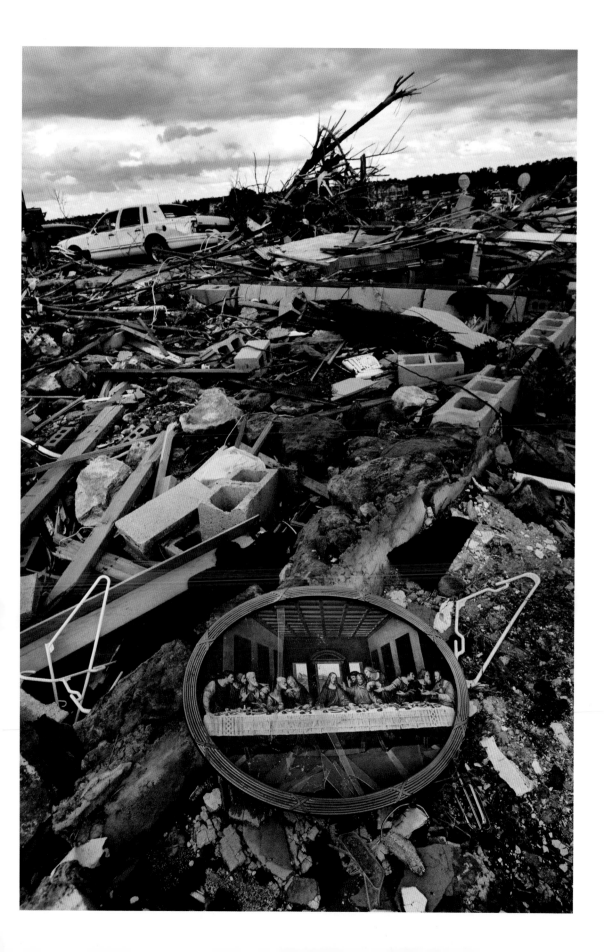

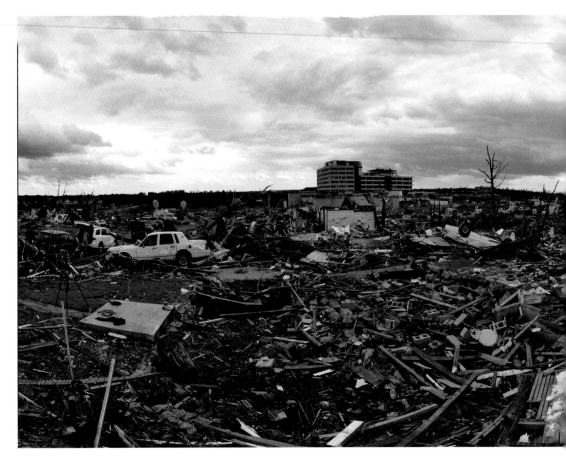

Landscape of Ruin

Panoramic image of wide-spread damage following the Joplin, MO, tornado.

I have three simple rules for surviving any type of disaster: (1) Know what dangers are possible in your area. (2) Know what to do for each specific threat. (3) Never delay if a serious threat occurs. Most people are killed or injured in disasters because they were either unaware of the threat or delayed taking action.

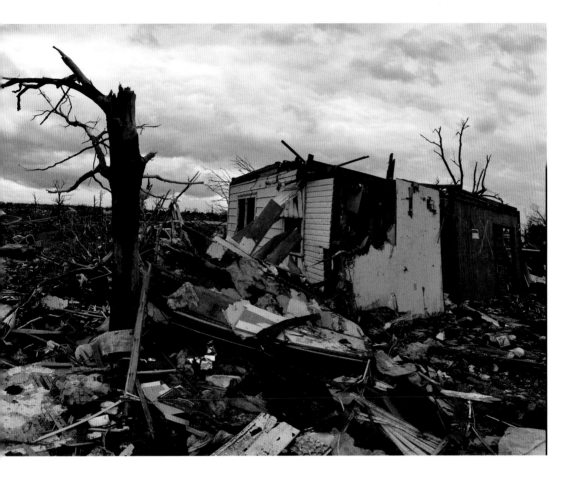

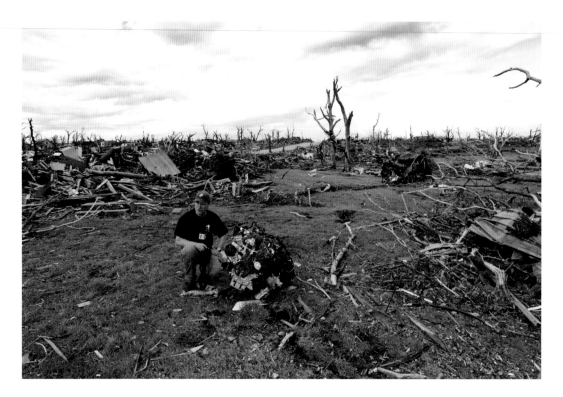

Extreme Winds

(top) This engine was ripped from the crumpled car seen in the background by Joplin's tornadic winds of over 200mph.

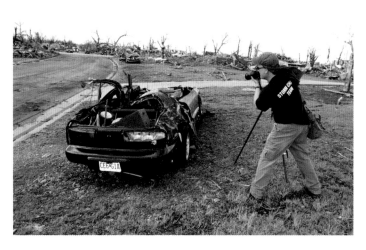

Educational Optics

(bottom) Part of my job is to find powerful pictures to use as educational optics. The image I am taking here illustrates that vehicles are not a good place to seek shelter during a tornado.

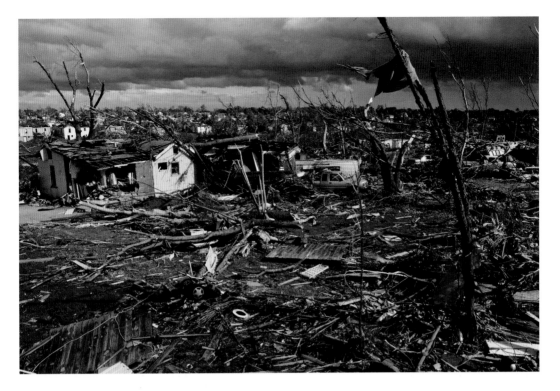

Nowhere to Hide

One of the reasons for the destructive and deadly nature of the Joplin tornado was the design of homes and buildings, as many were not built to survive the strong winds and flying debris.

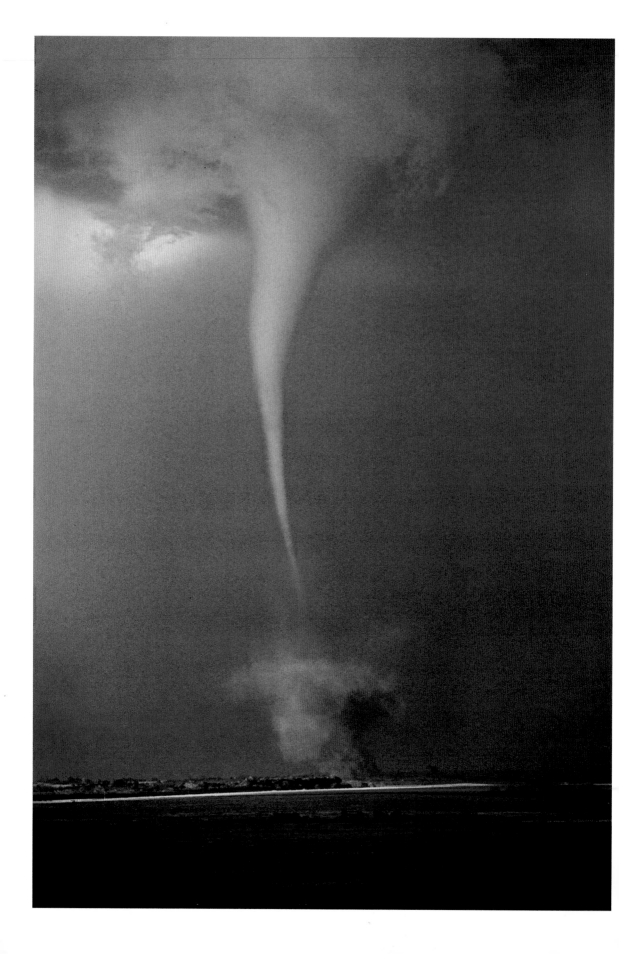

Camera Ready

(previous page) This tornado offered an enhanced photographic opportunity after it began picking up orange-red clay in western Oklahoma. Although an average of some 1,000 tornadoes occur each year in the U.S., not all of them are "camera ready." Many occur in thick vegetation, in darkness, or within heavy rain.

Dark Skies

(below) Storm clouds are always a challenge to photograph, as the majority do not offer the vivid colors and contrast I prefer. These dark and threatening clouds in western Texas supplied just enough contrast and color to make an interesting shot.

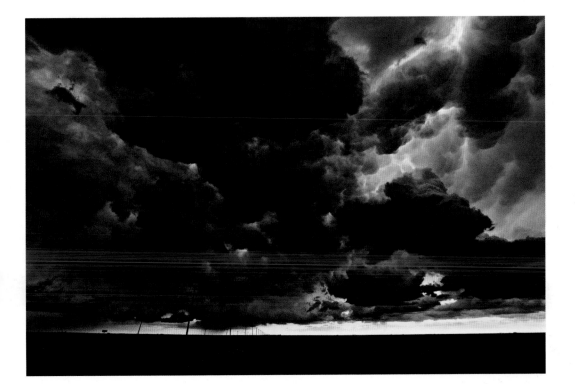

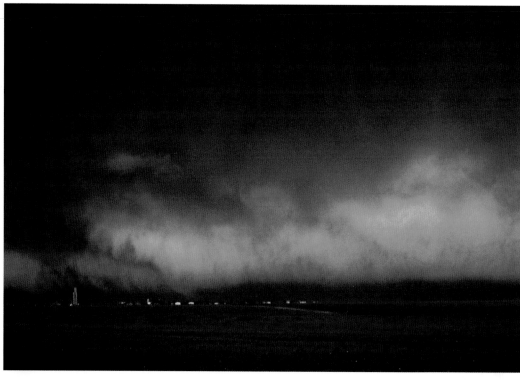

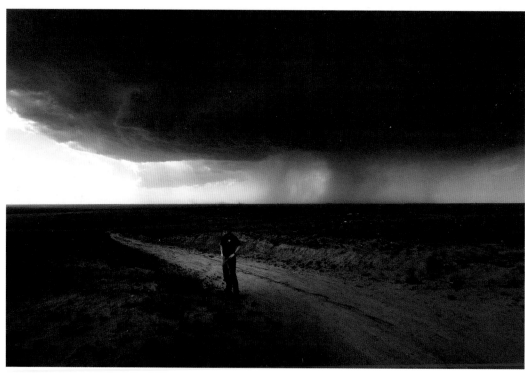

Sky Fall

(previous page, top) Low-hanging clouds from a passing storm, east of Amarillo, TX.

Supercell Backdrop

(previous page, bottom) Standing near a developing supercell storm in Oklahoma. Supercells are the most powerful land storms on earth. Usually consisting of a single, long-lived updraft, they are responsible for producing the most violent tornadoes.

Long Arm of the Law

(below) A lone cowboy stands guard over a small western Texas town as a storm looms on the horizon. One of my favorite things about severe weather photography is the travel. I never know what I may see on any given day. That unknown factor is a driving force of my passion.

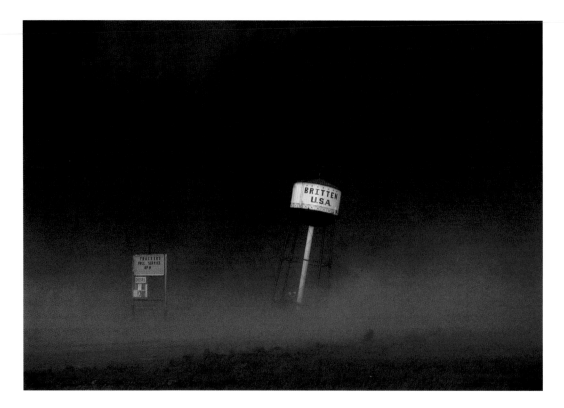

Dust Storm

Besides tornadoes, supercell storms can produce a number of hazardous offspring, including high winds and blowing dust, as seen near Conway, TX.

High winds are often an overlooked and underestimated weather hazard. Extreme winds from storms and weather systems are responsible for extensive property damage. High winds also contribute to the world's most deadly dust storms and wildfires.

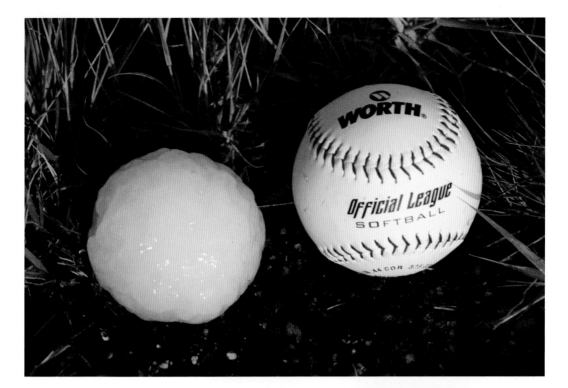

Hail Threat

(top) Large hail is a constant threat while working around big storms. This monster-sized hailstone fell in font of my vehicle as I was pursuing a tornadic storm in western Texas.

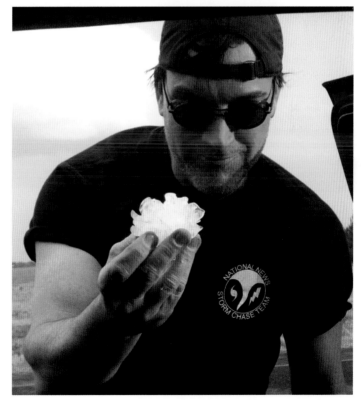

Iced Spikes

(bottom) I found this large, spike-covered hailstone near Seminole, TX.

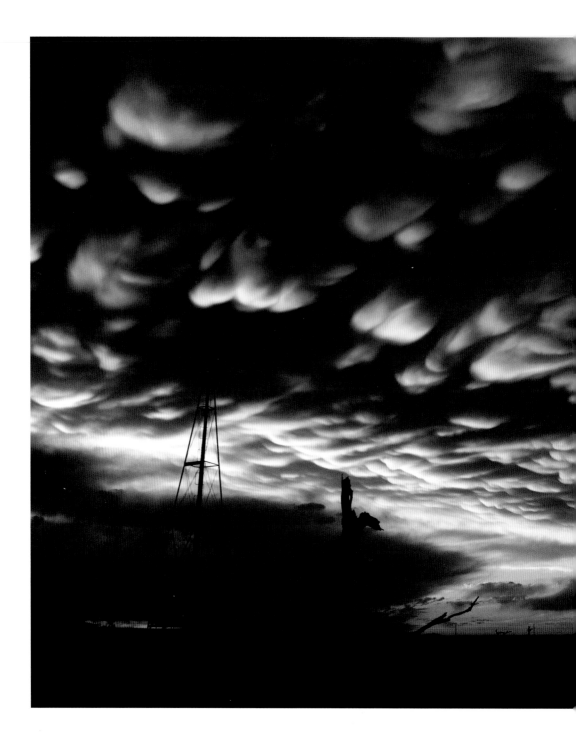

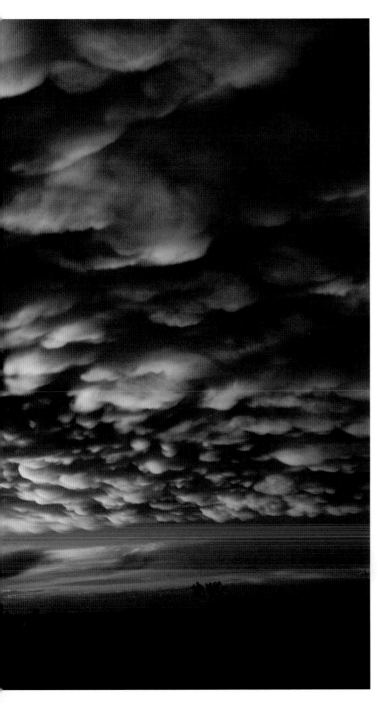

Bumpy Skies

"Mammatus" clouds seen at sunset over Amarillo, TX. The bulging clouds are highly sought after by storm photographers for dramatic images. They generally occur on the underside of "anvil" clouds, fanning out from a thunderstorm's upper region.

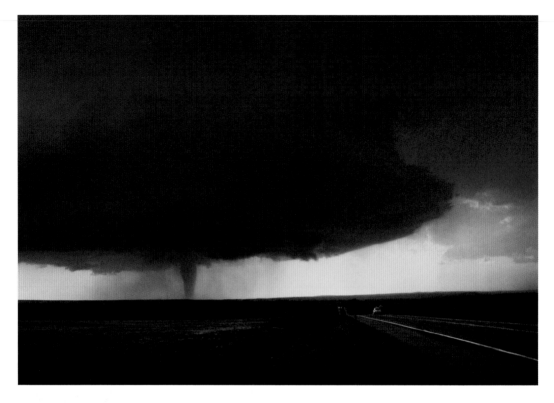

Colorado Tornado

A tornado near Simla, CO, moves over open farmland. The large, rounded cloud above the tornado is called a "wall cloud." The majority of strong tornadoes develop from such cloud formations as the storm's internal rotation lowers toward the ground.

Softballs

(right) This time, I was not so lucky. An encounter with softball-sized hail in western Kansas destroyed my windshield.

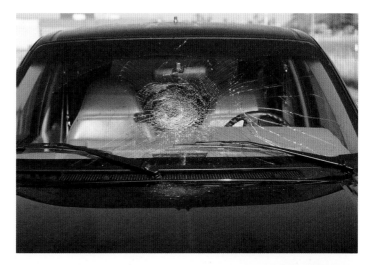

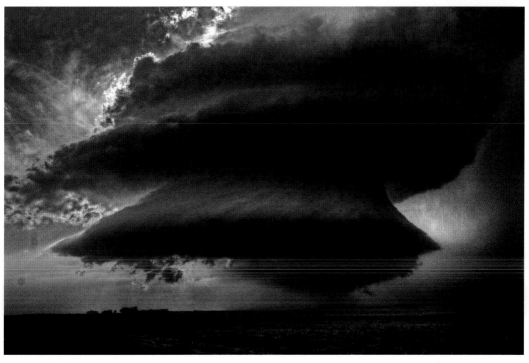

Wall Cloud

(above) Another great example of a wall cloud. This ominous-looking lowering did not produce a tornado, but signs of rotation are quite obvious. Near Greensburg, KS.

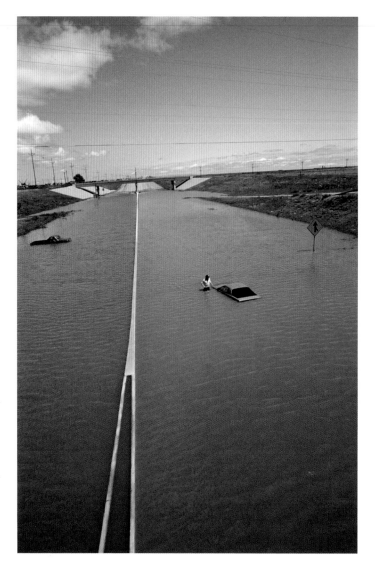

#1 Threat

(left) Flash flooding is the leading cause of weather-related deaths in the United States. This flooding was the result of severe nocturnal storms near Amarillo, TX.

Bonus Shot

(following page) Even if a long day of pursuing extreme weather is not productive, there is always the chance of a sunset-illuminated bonus shot.

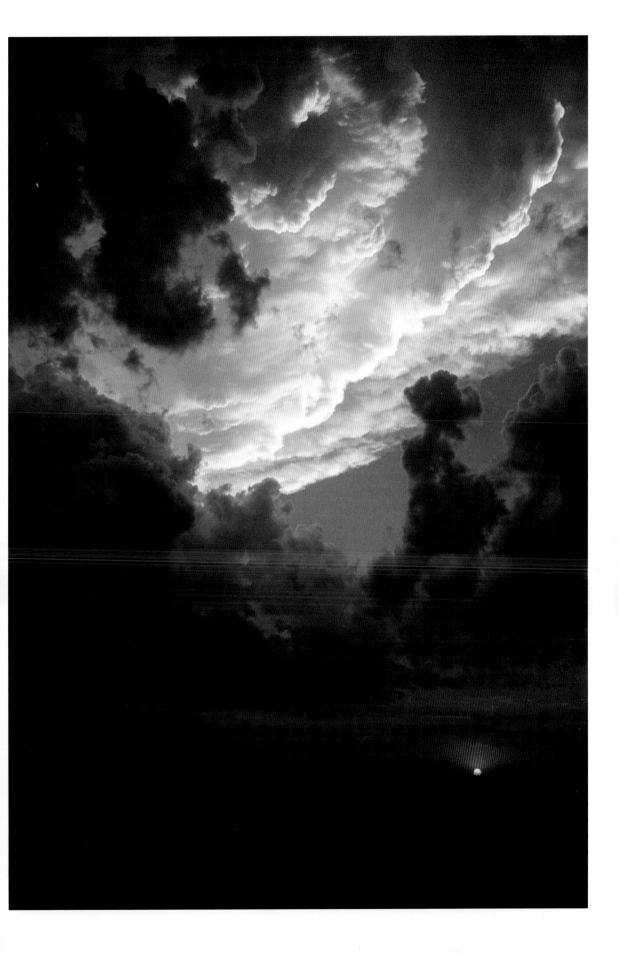

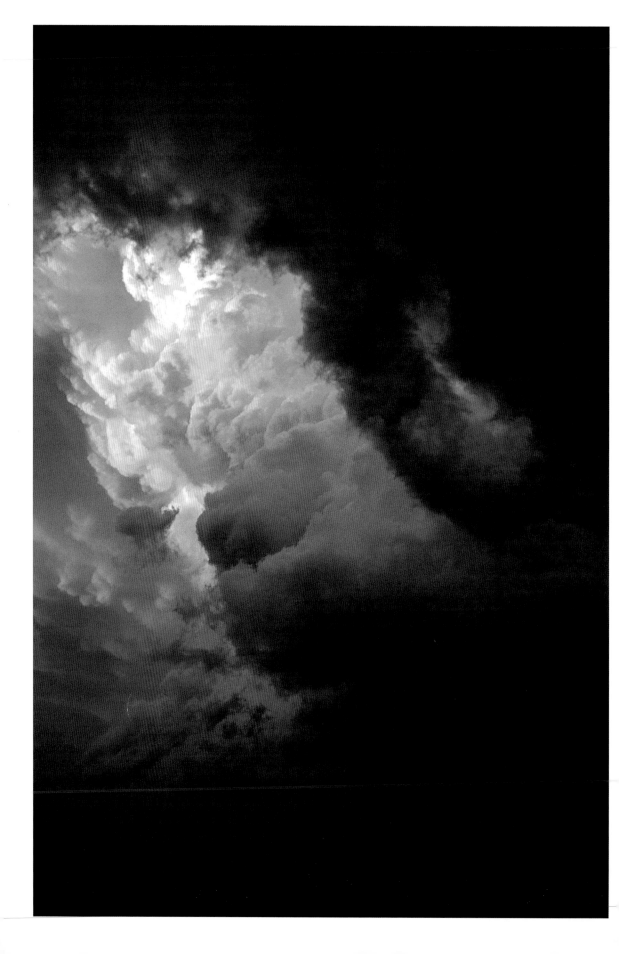

Light Fantastic

(previous page) The best cloud photography opportunities almost always occur toward sunset, when beauty light can bathe the clouds in vivid colors. Western Texas.

Stormy Tucson

(below) This severe storm slammed Tucson, AZ, with high winds and flash flooding. The dust storm provided an element of movement.

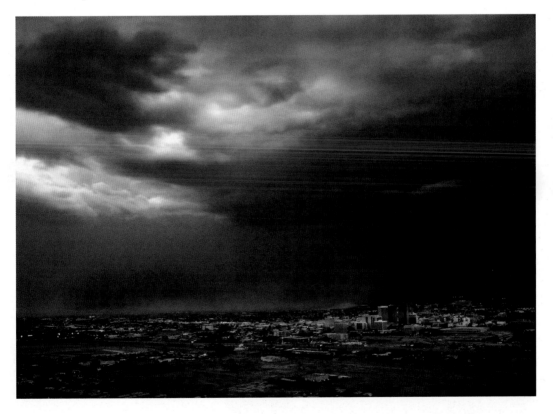

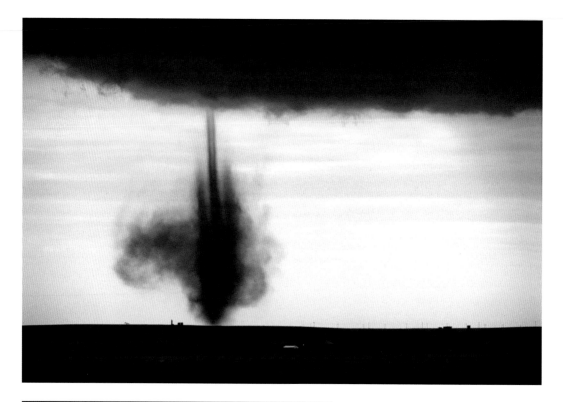

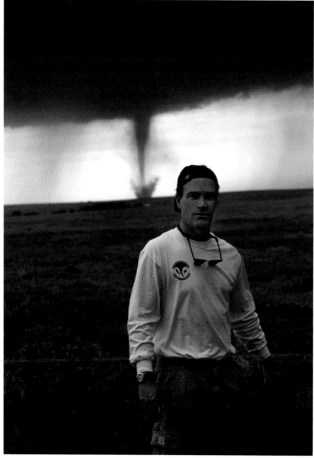

Landspout

(top) "Landspouts" are generally a weak type of tornado that forms under the low bases of thunderstorms. This landspout hovered above open fields in eastern Colorado just long enough to offer up this image.

Photobomb

(bottom) Never pass up an opportunity to photobomb a Colorado landspout.

Dust Devil

In contrast to tornadoes, "dust devils" do not originate from a thunderstorm's internal rotation. They form as rising hot air and surface winds combine to create a short-lived vortex, often made visible as dust and debris are ingested into the circulation. As a child, I would often ride my bike into dust devils around Tucson, AZ, for fun. Go figure!

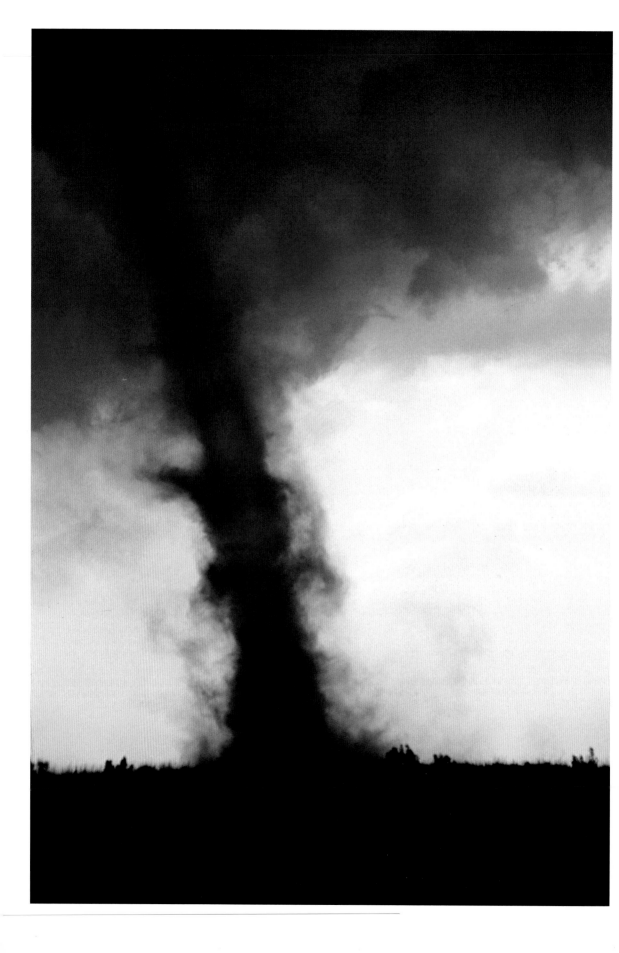

Oz Twister

(previous page) This tornado, photographed in Nebraska, reminds me of the famous studio-created tornado from the *Wizard of Oz*. The movie twister was a childhood visual I never forgot. I always knew I had to see a real one someday!

Special Effects

(below) I'm not a big fan of over-using HDR, or any effects, in my photography. This time, I could not resist, as the original "gloomy gray" scene needed an upgrade. Western Texas.

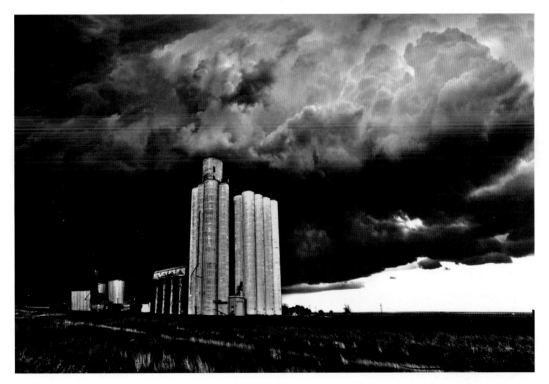

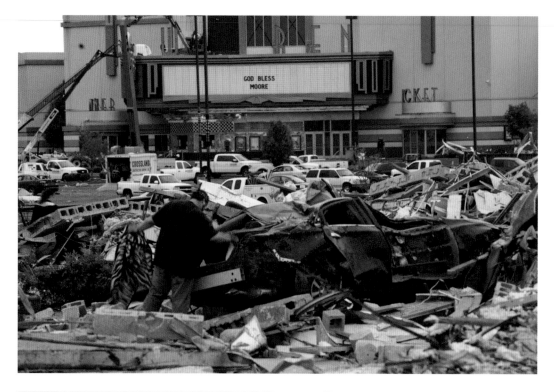

Moore, Oklahoma

(top) The statement on the theater marquee enhanced this editorial image following the May 20, 2013 tornado disaster in Moore, OK, that claimed 24 lives.

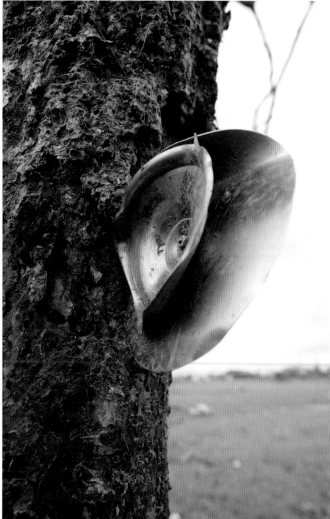

Flying Debris

(bottom) A metal object embedded in a tree trunk during the Moore tornado.

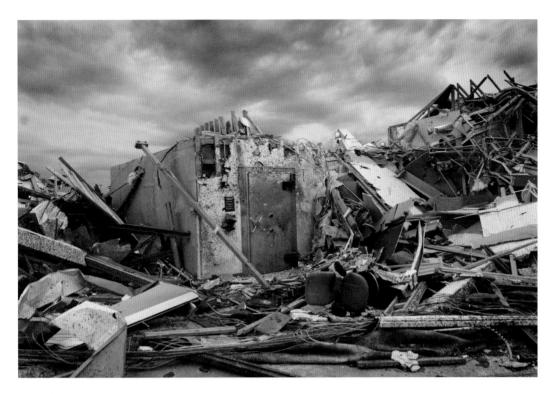

Survival Vault

A number of quick-thinking people took shelter in this bank vault as an EF5 tornado ripped through Moore, OK. Moore has been hit by violent tornadoes in 1999, 2003, and 2013. Unfortunately, the city exists in an area where violent supercell storms often reach maturity as they move in from the west.

Twister

This tornado occurred after a lone supercell storm formed near Miami, TX, in May of 1996. This image was eventually used as cover art for the motion picture *Twister.*

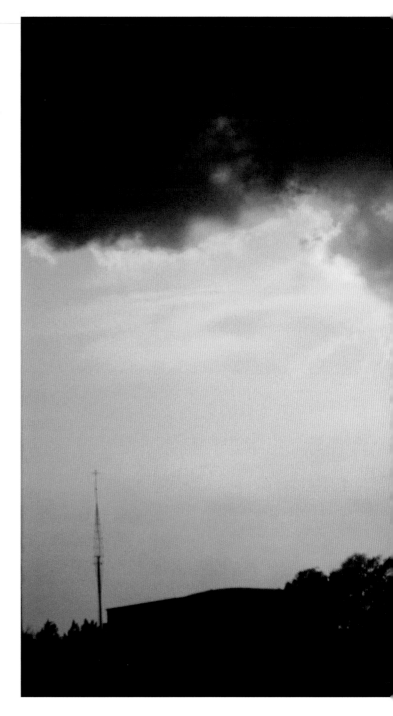

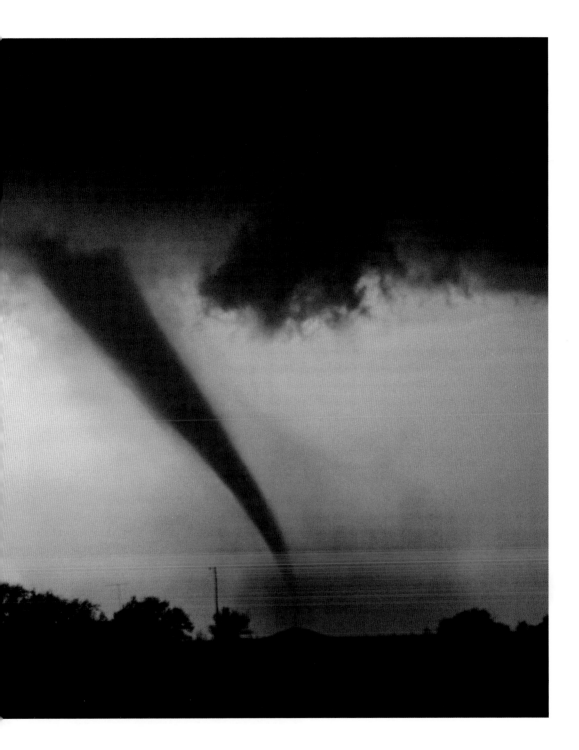

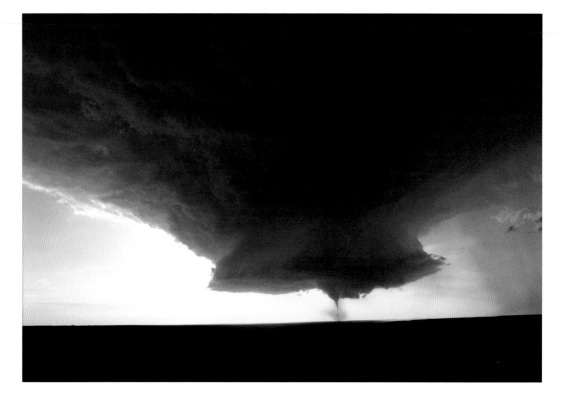

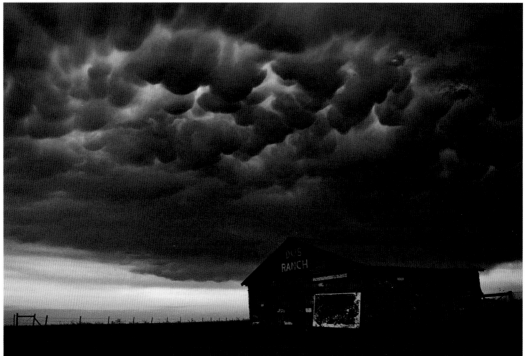

Ouch!

(previous page, top) The Miami, TX, tornado seen from a distance. As I was taking this image, I was pounded by golfball-sized hail. Seeking shelter from the hail in my vehicle, a sudden gust of wind slammed the door shut, nearly breaking my leg.

Turbulence

(previous page, bottom) Mammatus clouds fill the late-afternoon sky in eastern Colorado. Mammatus clouds are often a sign of extreme turbulence in the atmosphere.

Sky on Fire

(below) The glow from a distant orange sunset turns an otherwise benign sky of mammatus clouds into a spectacular image over western Oklahoma.

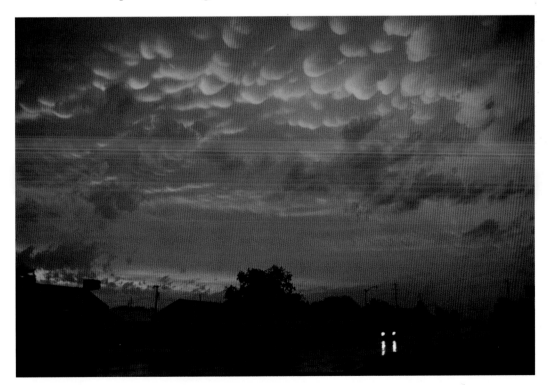

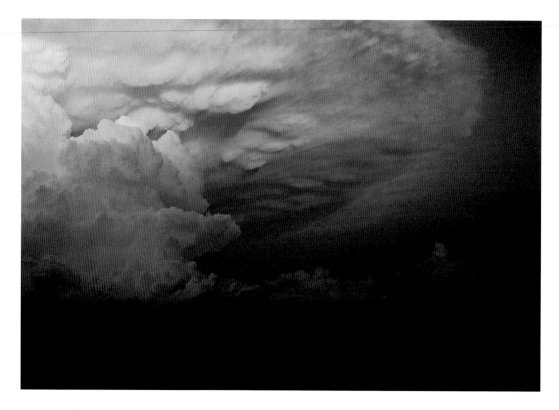

Dangerous Horizon

A distant, tornadic supercell develops near Wichita, KS.

Pursuing some of the planet's most dangerous storms requires patience, persistence, and thinking in three-dimensional space. Available road networks, storm development, and movement need to be constantly calculated in order to find the right perspective at the right time—all while factoring constant threats on the road and in the sky.

What the Hail?

(*top*) Why bother to pack your mattress in the moving van when you can tie it to your car's roof for hail protection?

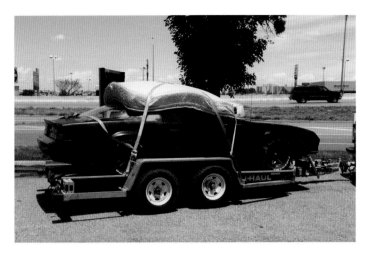

Hit Movie

(*bottom*) A VHS of *Twister* was spared the wrath of a tornado that hit Happy, TX, in May of 2002. As previously mentioned, the photo on the cover of the video box was taken by me in 1996 near Miami, TX.

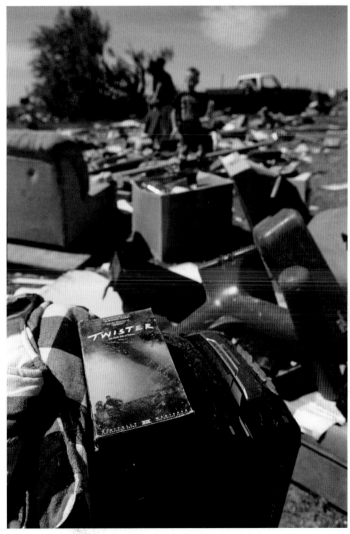

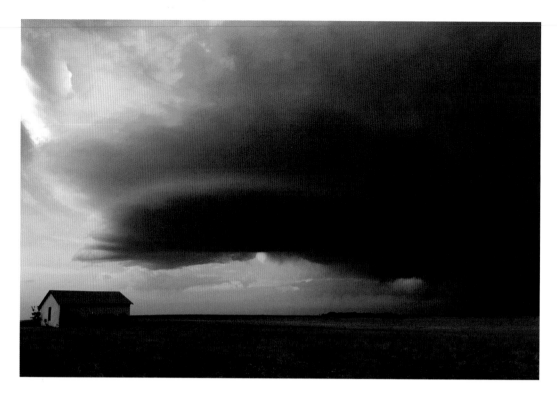

Talking House

(above) If only this lonely western Texas farm building could talk. I'm sure it could tell of many fantastic sights over the last century.

Fast Exit

(following page) Storm chasers prepare for a fast exit as a dangerous storm prepares to cross a Tornado Alley highway. Although most storm chasers are responsible individuals or groups chasing for various reasons, some are not so honest. Recently, a few chasers have been exposed as "fake" researchers. Instead of conducting life-saving research as claimed, they actually chase for self-promotion and to make a quick buck.

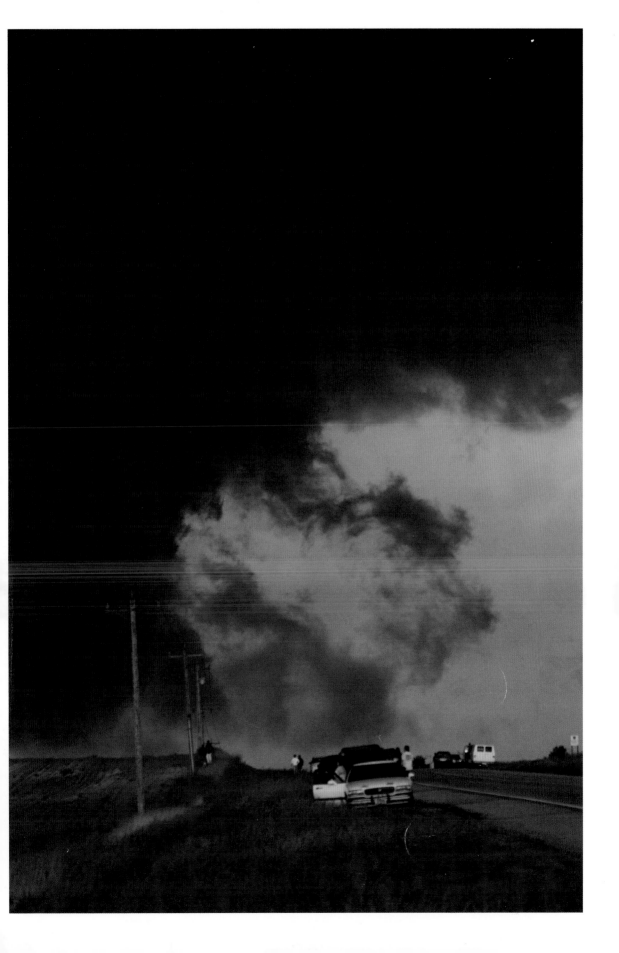

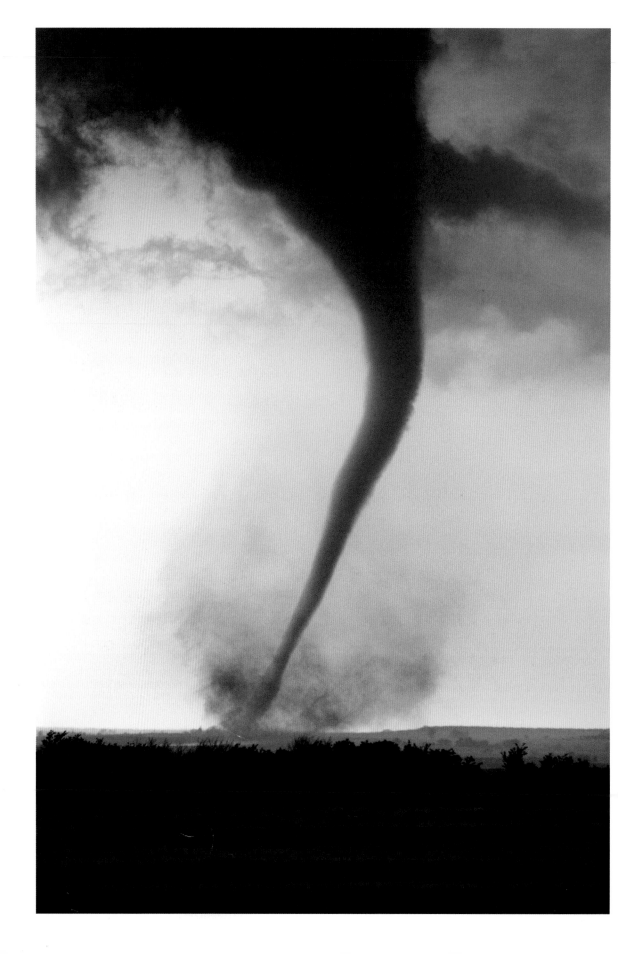

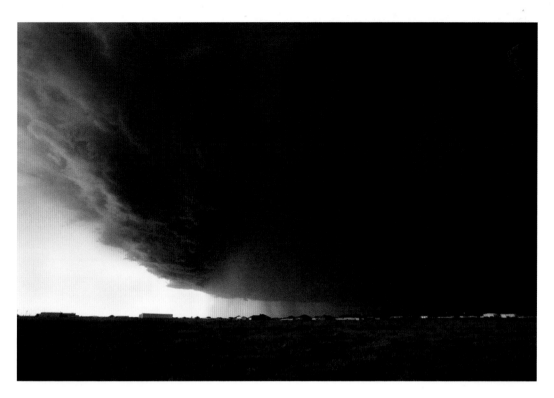

Vanishing Point

(previous page) A small but strong tornado moves across the open country of western Oklahoma. Since the average tornado lasts less than 10 minutes, a photographer must act quickly, or the entire scene will soon vanish.

Big Mouth

(above) Like a giant whale opening its massive mouth, a severe storm south of Amarillo, TX, prepares to engulf an entire community with high winds, big hail, and blinding rain. The art of storm photography is all about timing and finding the right angle for a good shot while leaving yourself an escape route—or two!

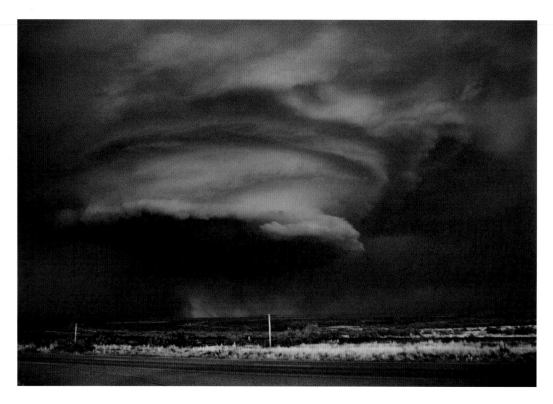

Spin Cycle

(above) A low-hanging wall cloud looms over far western Texas. Wall clouds are watched closely by storm spotters as the main source for tornadic development.

Neon Reward

(following page) Rainbows are often the reward after a long day of pursuing storms. This neon-bright rainbow formed as I was escaping hail and high winds. I pulled over for just a second and grabbed this shot.

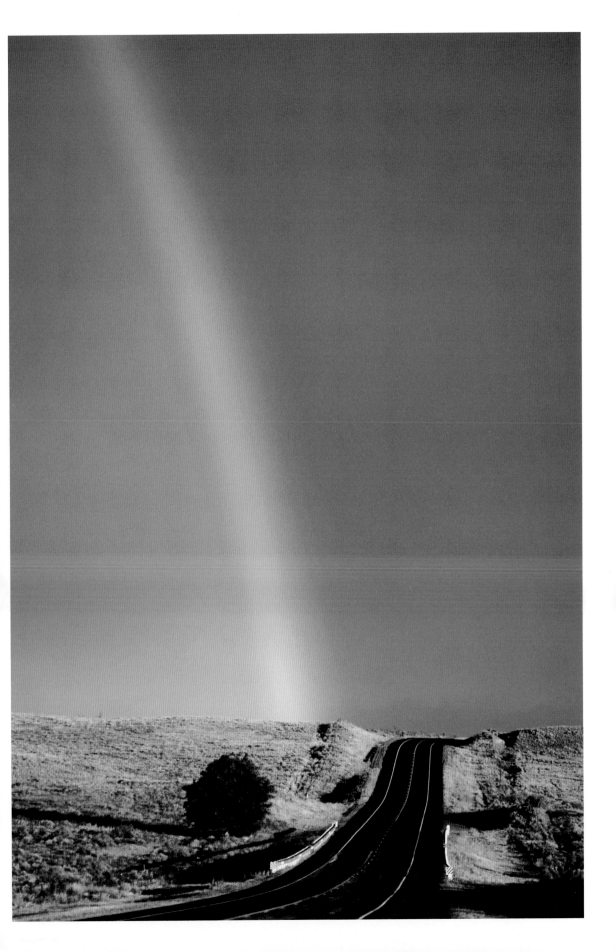

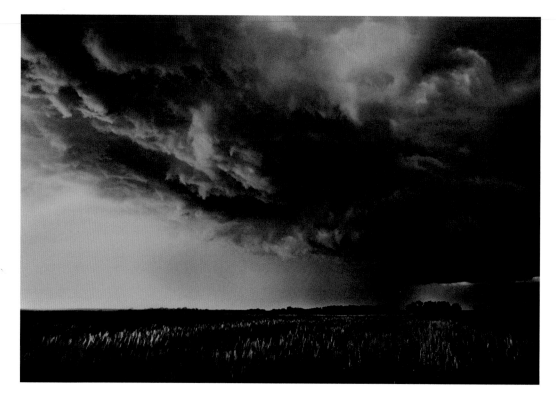

Color Blind

(above) Although some photographs don't translate well into black and white, the contrast and subject matter can sometimes create dramatic effects.

Cheyenne Twister

(following page) This photograph taken near Cheyenne, OK, in 2012 was rather drab in color, as very high humidity diffused the image. Converting to black and white added contrast and made the shot appear more threatening.

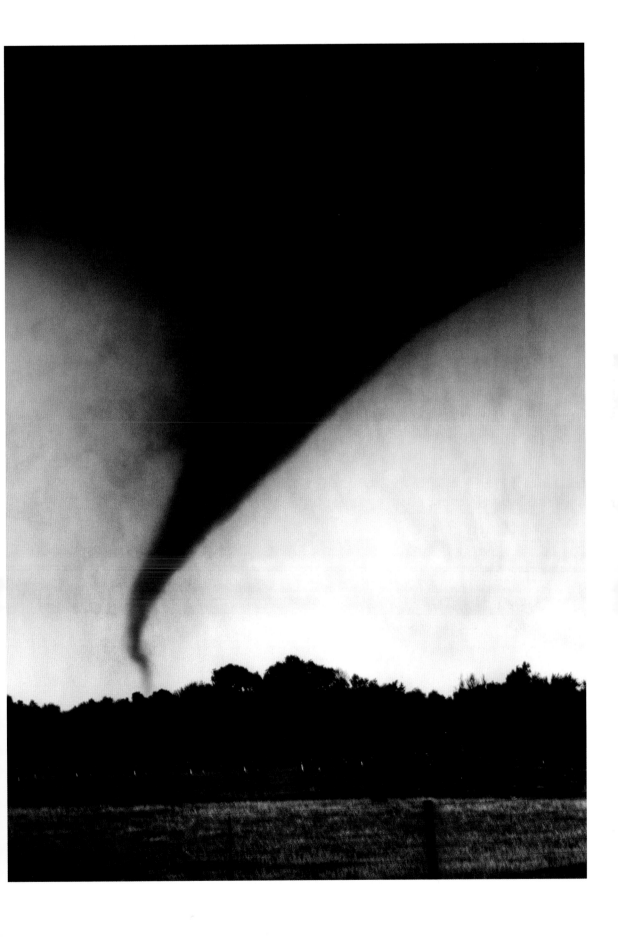

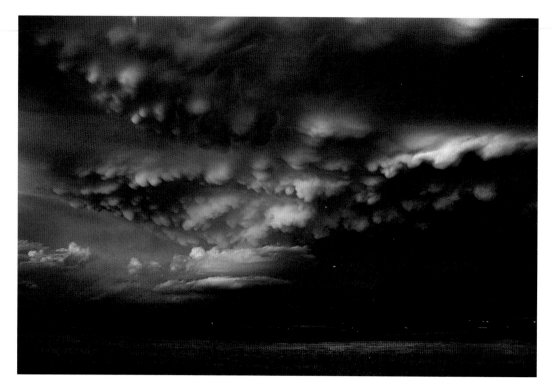

Beauty Light

When the sun sets, anything can happed in the sky. Boring and flat gray skies can sudden-ly come alive as beauty light spreads across the horizon. I always try to position myself in a favorable location as the sun sets.

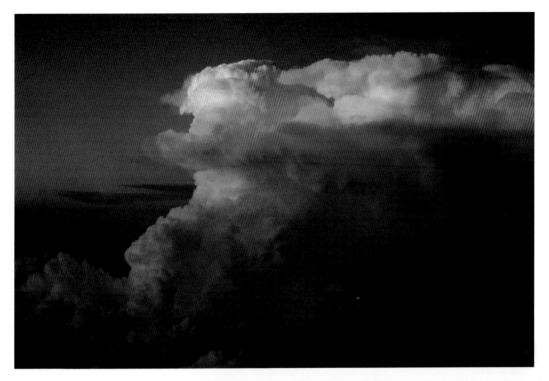

Point and Shoot

(top) I always carry a high-end point-and-shoot camera with me when I fly. This beautiful picture of storm clouds over Texas was the result.

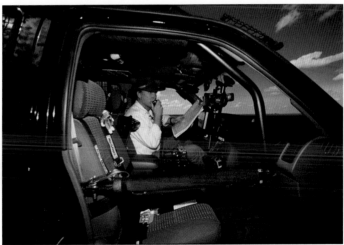

Intercept Vehicle

(bottom) The view inside one of my past camera vehicles, complete with a roll cage and a host of communication and camera/video equipment. As the years have passed, light-weight digital equipment has made things a lot easier to manage.

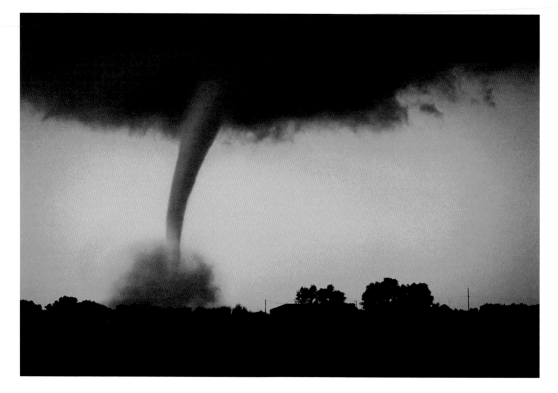

Favorite

One of my favorite tornado images, taken near Attica, KS, on May 29, 2004. I love the contrast and colors (no filters) and the perfectly shaped tornado. I also shot this tornado on 35mm motion picture film. It was one of the few tornadoes ever captured on 35mm format. (I shot the first in 1997.)

Fortunately, this tornado remained over open country and caused no serious injuries or property damage. It's always easier to celebrate a classic image when the conditions produce no harm.

Photobombing a Twister

Shooting the Attica, KS, tornado on 35mm motion picture film. Yes, I was lucky I had time to set up the movie camera (it was crazy heavy), film the twister, then set up a second tripod and take this self-portrait. One learns quickly to multi-task as a storm-shooting photojournalist. Technological advancements in high-quality, palm-sized cameras have made it a lot easier to capture dramatic imagery. Nowadays, anyone can capture extreme events without professional training. For many professional photographers, this was the end of the "golden years."

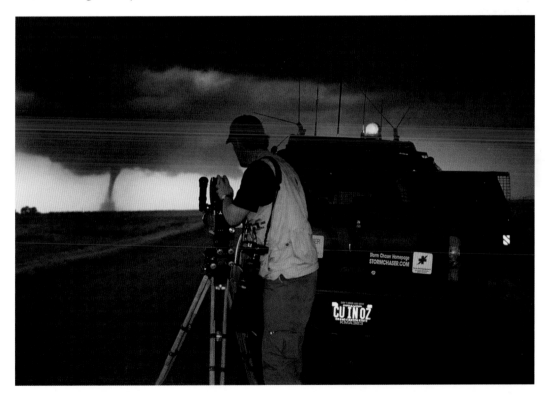

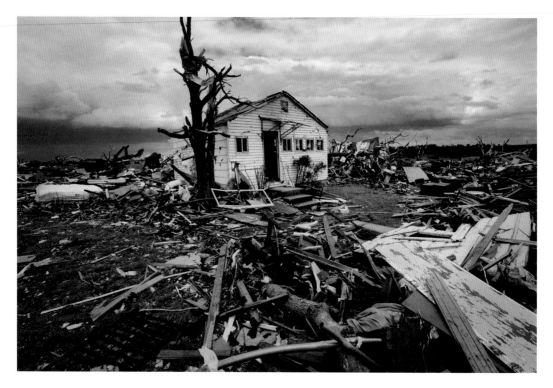

Lucky Survivor

(*above*) We always hear stories about the "one house" that survived a massive tornado while the neighboring homes were demolished. Here is proof it actually happens. A man in Joplin, MO, survived the deadly 2011 tornado while remaining in this house as debris shot through the walls.

Surgical Precision

(*following page*) The damage from tornadoes can be brutal or as gentle as a surgeon's hand. A stick was driven cleanly through this plastic cup as a tornado hit Happy, TX, in 2002.

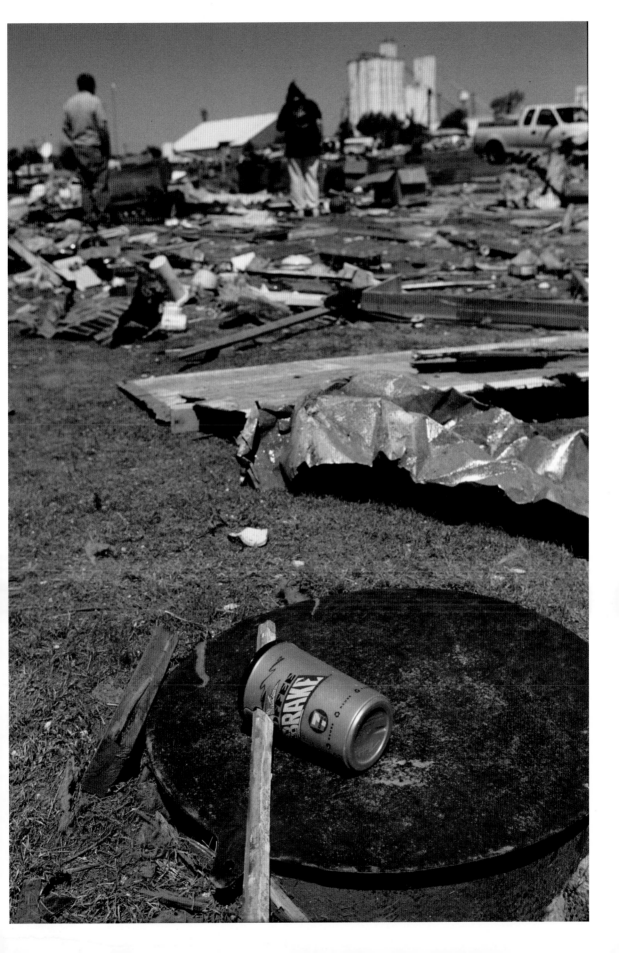

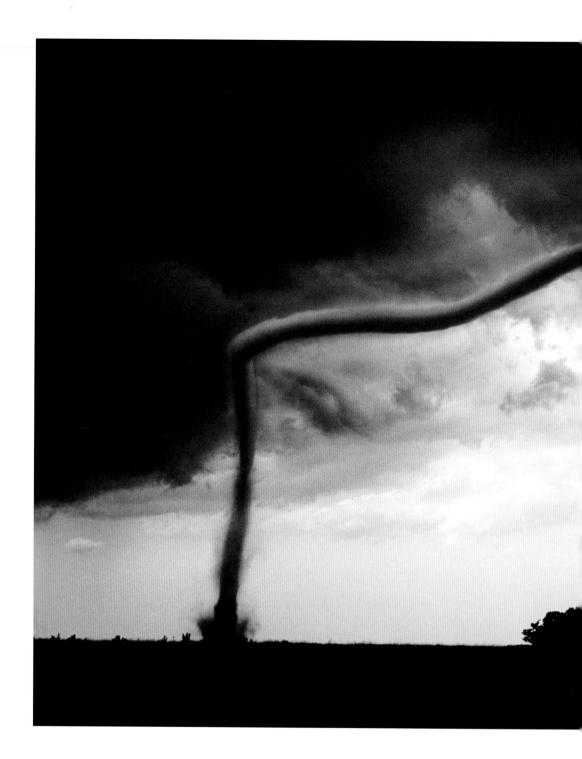

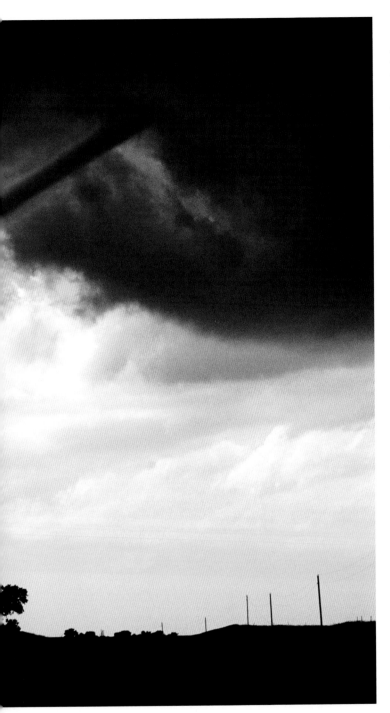

Mesmerized

I became so mesmerized by this long, snaky tornado with movements of cloud fragments along the funnel, I nearly let it run me over. I had conducted a mammoth drive the day before, traveling all the way from Abilene, TX, to Iowa after a laptop failure. My forecast and travel paid off.

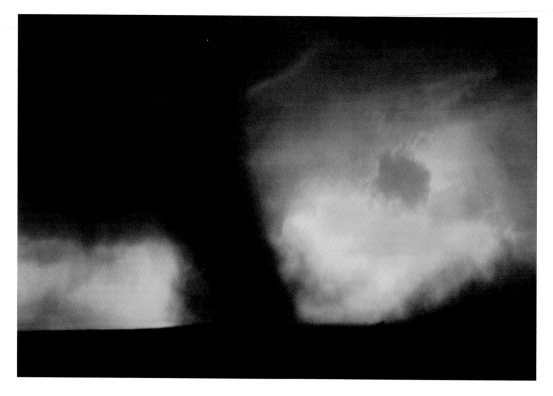

Turkey Tornado

(above) This tornado near Turkey, TX, was very brief, but allowed for one good frame. I always use high-quality, fast zoom lenses for shooting severe weather. I simply don't have time to mess with fixed-focal-length lenses, nor do I really want to expose a camera's internal parts to blowing dust while changing lenses.

Technology Gap

(following page) I'm constantly amazed at the amount and size of equipment once required for professional photography. Digital cameras, laptops, cell phones, GPS, and modern technology have made my work so much easier and safer.

This image was taken in the late 1980s at the beginning of my career. The frown is due to driving hundreds of miles and getting little sleep.

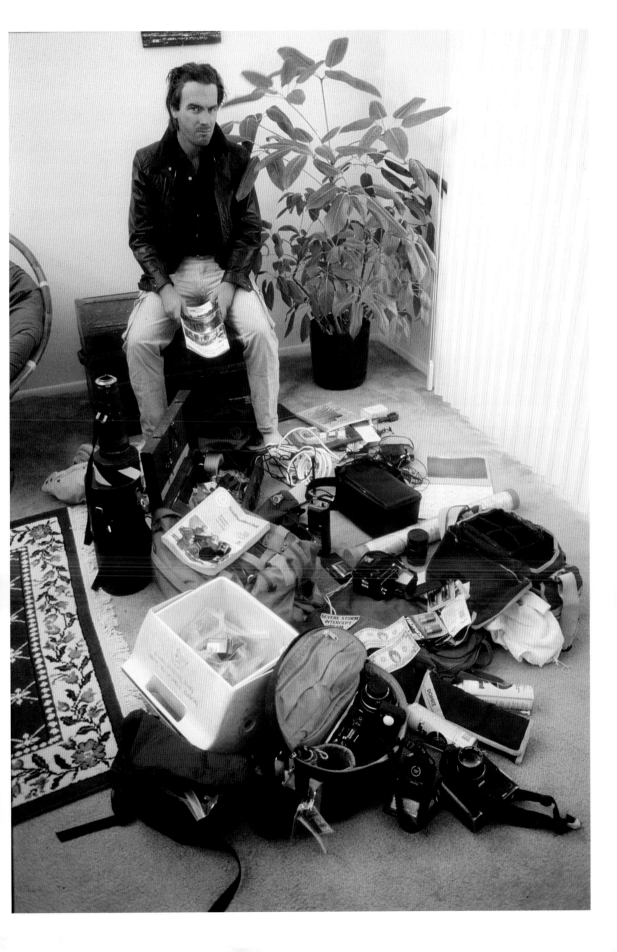

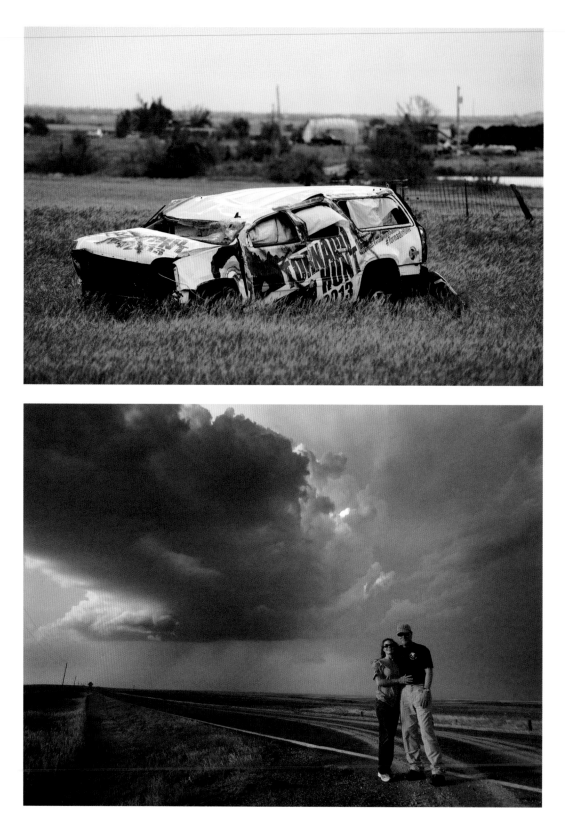

Tragic Day

(previous page, top) This chase vehicle from The Weather Channel was swept off the road by a tornado near El Reno, OK, in May of 2013, injuring several occupants. The main tornado produced winds measured at 295mph by a mobile research unit. Eight people were killed, including three severe weather researchers—the first storm chasers killed by a tornado.

Chase Adventure

(previous page, bottom) My wife Heather and I near a severe storm in Kansas. In 2001, I began offering private chase adventures to allow people to go tornado chasing with me.

Tornado Outbreak

(below) A strong tornado narrowly missed a farmstead in central Oklahoma during a killer tornado outbreak in May of 1999. Another tornado struck the Moore, OK, area, killing 36 people. Winds in that tornado were measured at 301mph, the highest naturally generated winds ever measured on earth.

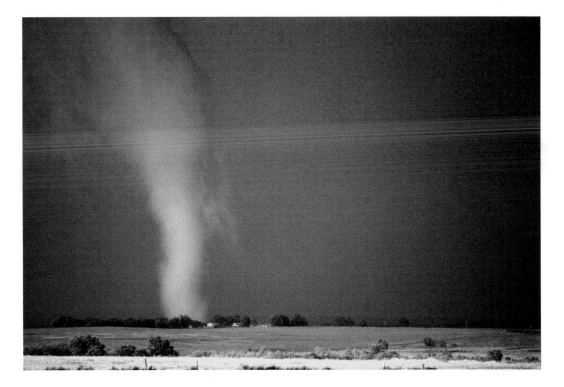

HURRICANES and FIRES

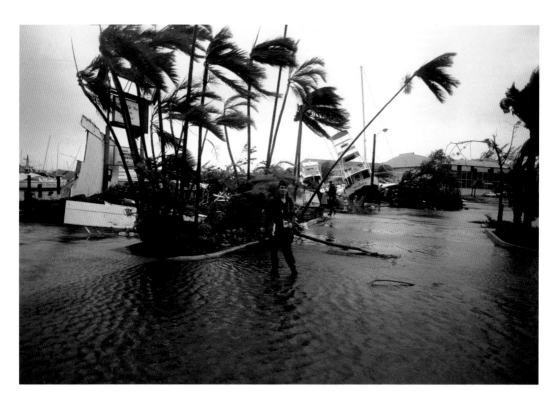

Catgory 5 Opportunity

Very few photojournalists have had the opportunity to work in a Category 5 hurricane on U.S. coastlines. This is mainly because Cat-5s are very rare, with only three such storms ever hitting the U.S. mainland—the "Labor Day Hurricane" in 1935, Camille in 1969, and Andrew in 1992. I had my opportunity with Hurricane Andrew in Coconut Grove, FL.

Timing is Everything

Still images of Hurricane Andrew are quite rare. There are several reasons for this. The winds of some 170mph made photography attempts extremely hazardous, the storm was nearly over by sunrise, and most importantly, there were very few professional photojournalists covering the storm.

Gauntlet of Pain

(top) This rare photograph is one of the few taken while Andrew was still producing hurricane-force winds, which ended shortly after sunrise. To accomplish this image, I was subjected to a gauntlet of not-so-fun storm tortures. This included cuts from flying glass, having my arm painfully smashed against a railing, and a host of flying debris narrowly missing my body.

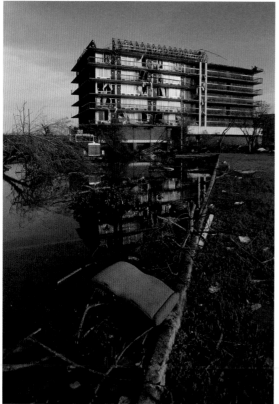

Ground Zero

(bottom) The Homestead, FL, area suffered some of the most extensive damage from Andrew.

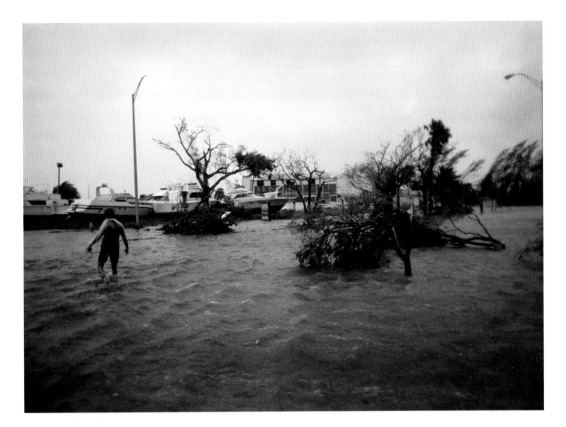

Searching

As a photojournalist, I'm always looking for people to include in my frames. Unfortunately, with insane storms, very few people venture out where I am. I found this man wading through Hurricane Andrew's storm surge seeking out a person he said "was missing."

One of the freedoms I enjoy with working for myself is that I can always stop shooting if someone is uncomfortable, or I can put down the camera and work as a first responder.

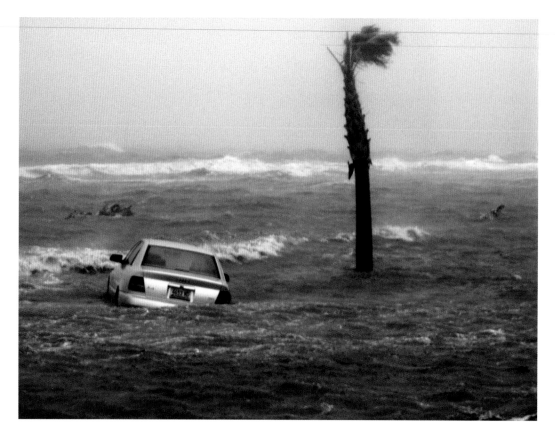

Boatmobile

The rule for vehicles versus hurricanes: cars float, but not for long. Fortunately, no one was in this vehicle as Hurricane Gustav struck Gulfport, MS, in August of 2008. I've witnessed hundreds of cars destroyed by storms and natural disasters including fires, hail, earthquakes, floods, tornadoes, and even ice storms. It's important to avoid developing a false sense of security that your vehicle is indestructible.

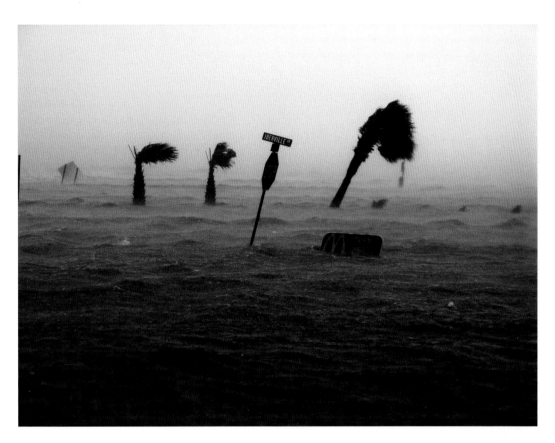

Surge Hazards

(top) Working in a storm surge is a tricky and dangerous business, but it produces the type of images that few photographers dare to take. I always survey a suspected storm surge area in advance of a storm. I make note of electrical hazards, man hole covers, and other drains that could sweep a person under the water.

Pit of Doom

(bottom) One of the dangers of walking in storm waters where you cannot see the bottom. Falling into this open manhole would be a fatal mistake. Following Hurricane Andrew in Biloxi, MS.

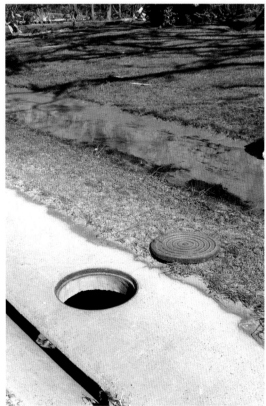

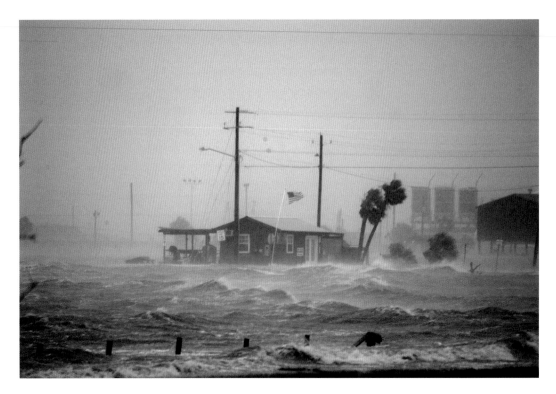

Three Elements

(above) Sometimes it is difficult to capture the three main elements of a tropical cyclone: destructive winds and storm surge. Most hurricanes do not produce dramatic images until the winds approach 100mph, which just happens to be the same speed at which it is very challenging to stand and debris begins to fly. Hurricane Gustav.

Trading Shots

(following page) Shooting hurricanes is usually a lonely, wet business. I was fortunate during Hurricane Gustav in Gulfport, MS, to find a passing individual so we could swap action portraits.

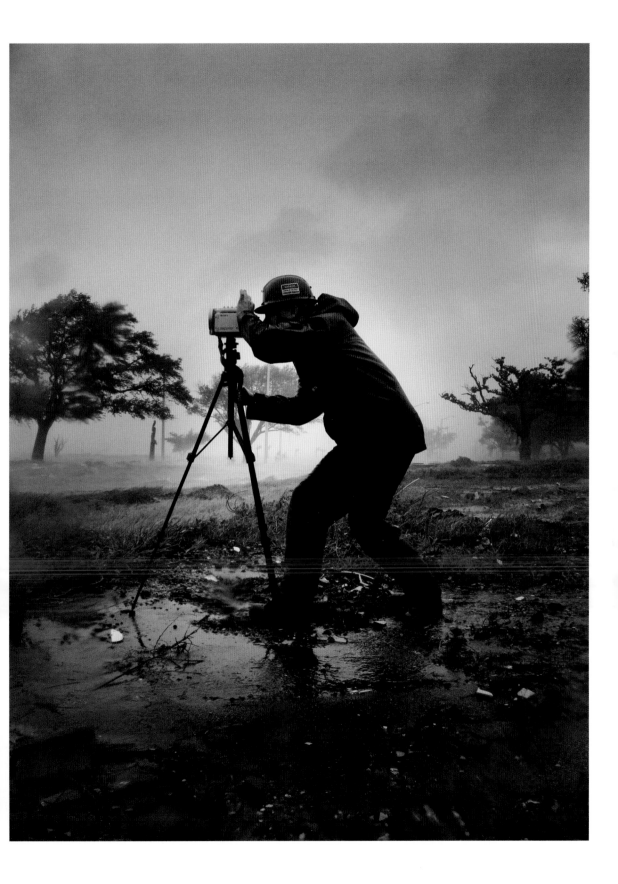

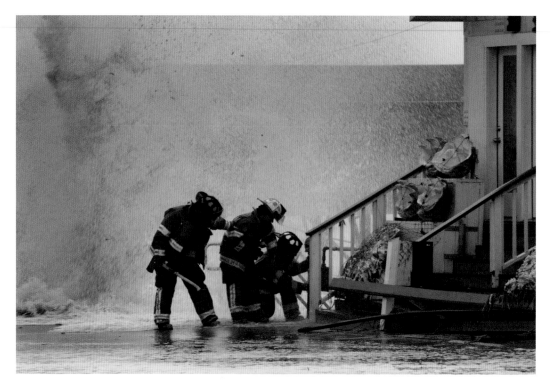

Hazard Pay

(above) Working near storm surges or large waves breaking on sea walls poses many dangers. Firefighters were pounded by huge walls of water as they secured a broken gas line as Hurricane Ike battered Galveston, TX, in September, 2008.

Wet and Wild

(following page, top) Utility workers are confronted by a massive tower of sea water as they inspect a building along the coastline during Hurricane Ike.

Fire and Water

(following page, bottom) A man attempts to access a boat storage facility as flames engulf the building during Hurricane Ike.

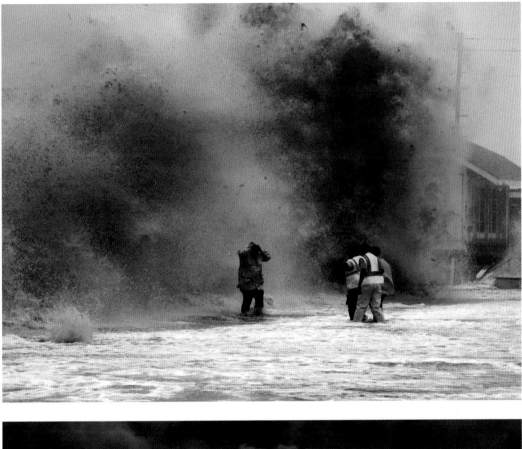

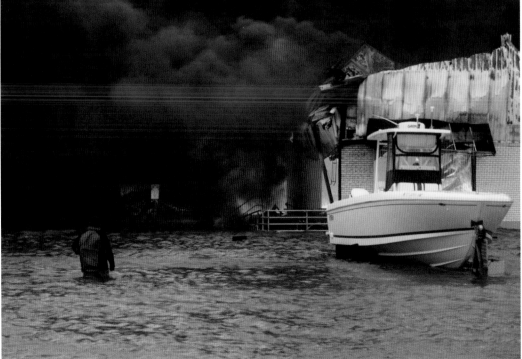

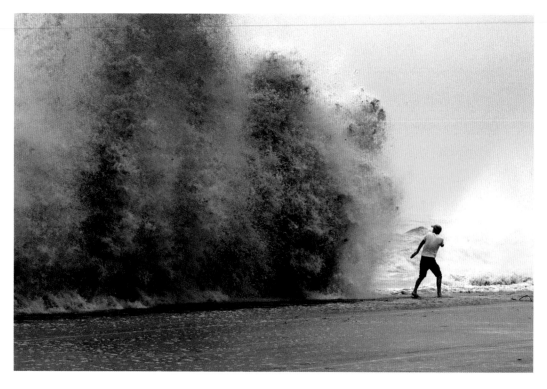

Wave Goodbye

Every hurricane strike zone has the following: a restaurant, hotel, and bar that stays open no matter how bad the outlook. There is also at least one daredevil who finds a way to make my pictures interesting. This fellow figured it was fun to brave the massive sea-wall waves during Hurricane Ike, until someone pointed out to him that the spray was filled with exciting things like huge pieces of a recently destroyed pier. This is not to say I'm immune to "acts of brilliance." I once ate lunch on a dare at a cafe located on an old wood pier during a hurricane as it rocked and creaked from huge waves.

Shark Alert

As the winds from Hurricane Ike began to diminish, there were multiple reports of a "great white shark washed up on the beach." Needless to say, I ran to the area expecting a front-page shot. The reports were *kind of* true, except the shark was from a flooded miniature golf course.

On the serious side, misinformation during a disaster is a serious public hazard. It's always best to rely on established sources of information when making life-and-death decisions.

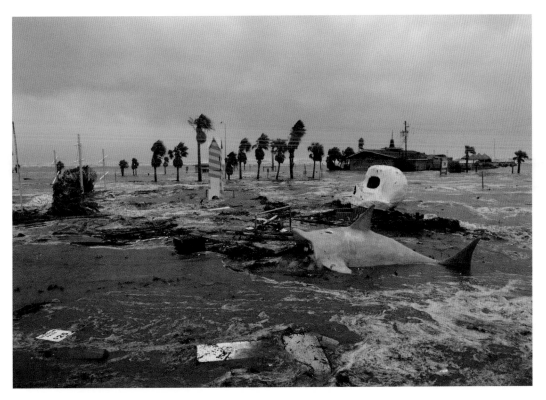

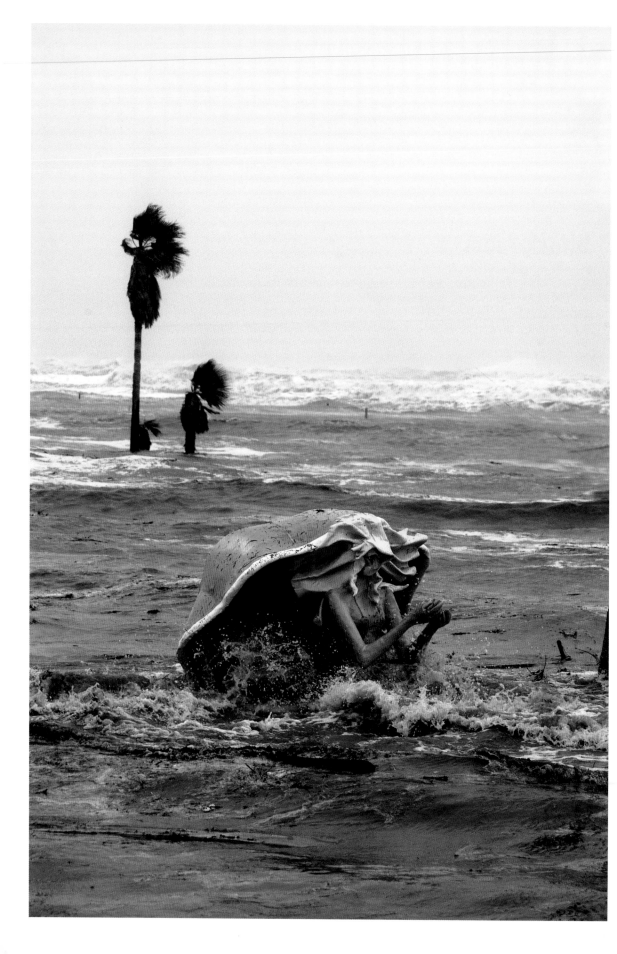

Freedom

(previous page) Ike's storm surge sets a mermaid free from a miniature golf course.

Neptune's Defiance

(below) King Neptune raises his arm in defiance as Hurricane Ike crashes against the Galveston seawall. In 1900, a powerful Category 4 struck Galveston, killing some 6,000 to 12,000 people. It was the deadliest natural disaster in U.S. history. This monument was dedicated in memory of the storm, including an orphanage washed away by the hurricane.

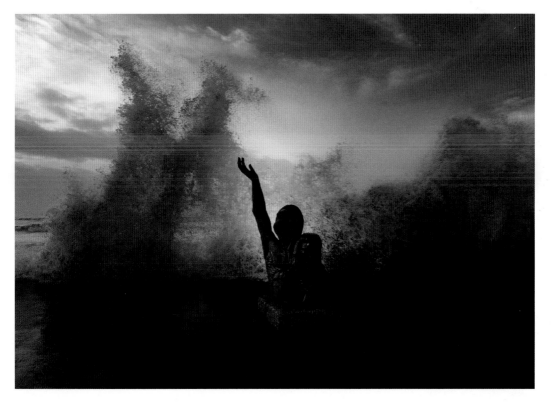

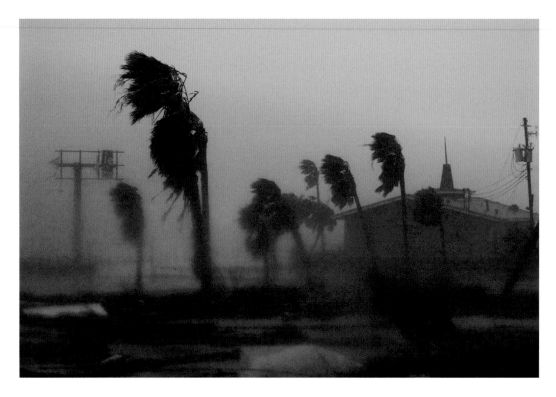

Coconuts

Hurricane Ike's full fury bears down on Galveston.

I always try to incorporate bending palm trees in my hurricane shots because they symbolize "tropical" weather and help capture the force of the wind. Falling coconuts and palm fronds are defeated by wearing a helmet.

My work requires constant attention to my surroundings. During Hurricane Frances in Juno Beach, FL, I was nearly swallowed by a boardwalk sinkhole. I avoided certain doom by making a last-second leap to a nearby chain link fence as the ground disappeared below me.

Wasteland

A mountain of debris from docks, buildings, and piers destroyed by Ike line the coastal highway.

Navigating through post-disaster debris is a tricky and hazardous task. Rusty nails, glass, strange-smelling chemicals, enraged fire ants, and electrical lines of unknown danger are common. Occasionally, I'll find living sea animals in the debris and I'll toss them back into the water—excluding jellyfish!

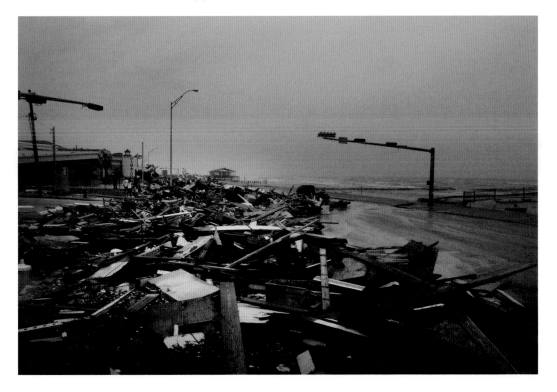

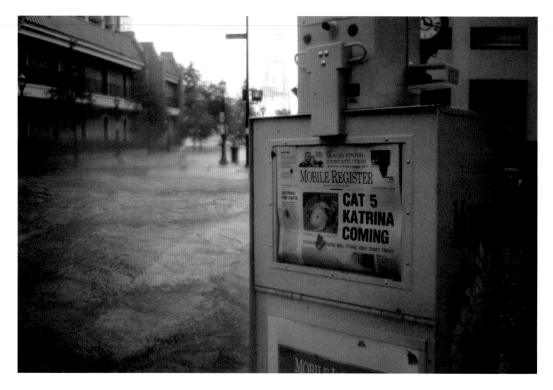

Hurricane Coming

I pursued Katrina along the Gulf Coast from Mobile, AL to Gulfport, MS. In Mobile, I saw this newspaper stand from a distance and prayed there was a newspaper inside of it to make the shot.

Wrong Way

It's always a rather interesting feeling to be traveling toward the eye of the storm on the deserted side of a highway as millions of people head inland on the other side of the road.

The largest "ordered" hurricane evacuation in U.S. history occurred during Hurricane Irma in September of 2017, when over 6.3 million residents were ordered by the Florida Governor to move inland. It may never be known how many people actually heeded the order.

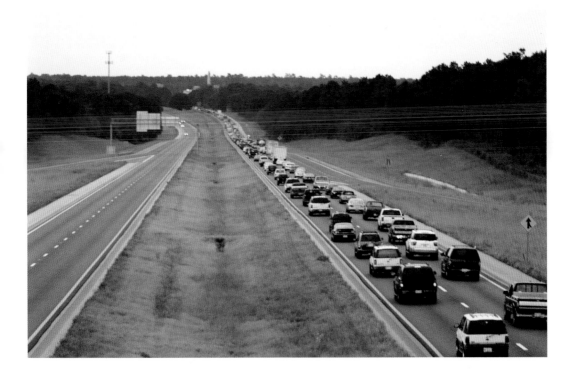

Katrina Strikes!

Hurricane Katrina strikes downtown Mobile, AL, with destructive winds and a storm surge of over 11 feet.

Katrina will be mostly remembered for the deadly flooding it caused in New Orleans after several critical levees broke. The final death toll was 1,577. However, the most serious wind and storm surge damage occurred along the Gulf Coast regions, including Biloxi and Gulfport, MS, killing 238 people. I will never forget the urgent calls over public radio pleading for "anyone with a boat to respond to New Orleans" following the storm.

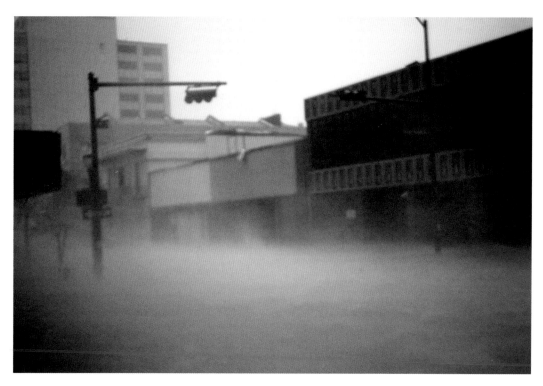

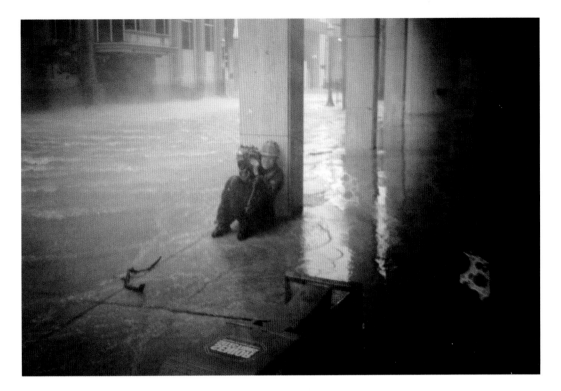

Sitting on the Job

Katrina's extreme winds forced me to sit with my back against a building's support pillar as I endure debris and stinging rain in Mobile, AL.

The physical demands of covering a hurricane are punishing. During the off season, I work out extensively with this in mind. I also practice water survival skills by jumping into a pool with all my gear on to make sure I don't sink like a rock.

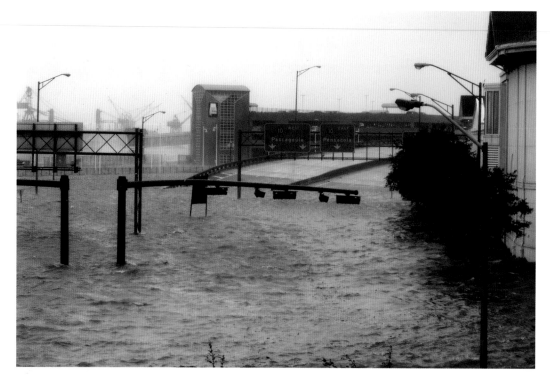

Overflow

(above) Mobile Bay is forced into the downtown area as Katrina's storm surge inundates the Gulf Coast.

Missing Floors

(following page) The power of Katrina's destructive storm surge is best illustrated in this image as a lone figure stands above two missing lower floors, completely wiped clean by Katrina's 27-foot storm surge in Biloxi.

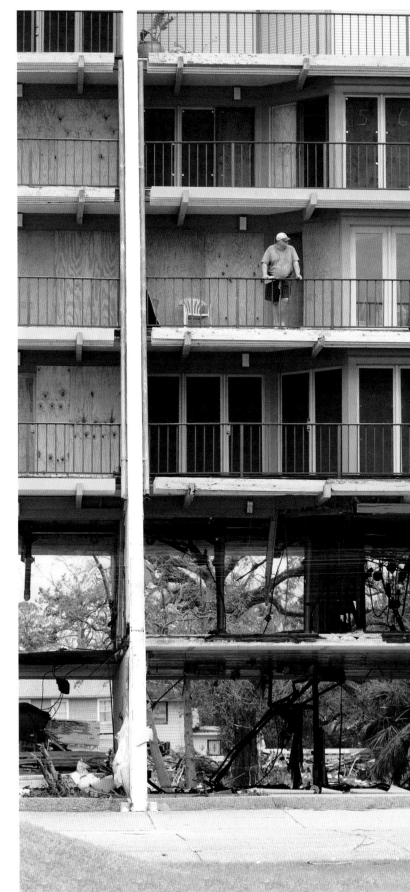

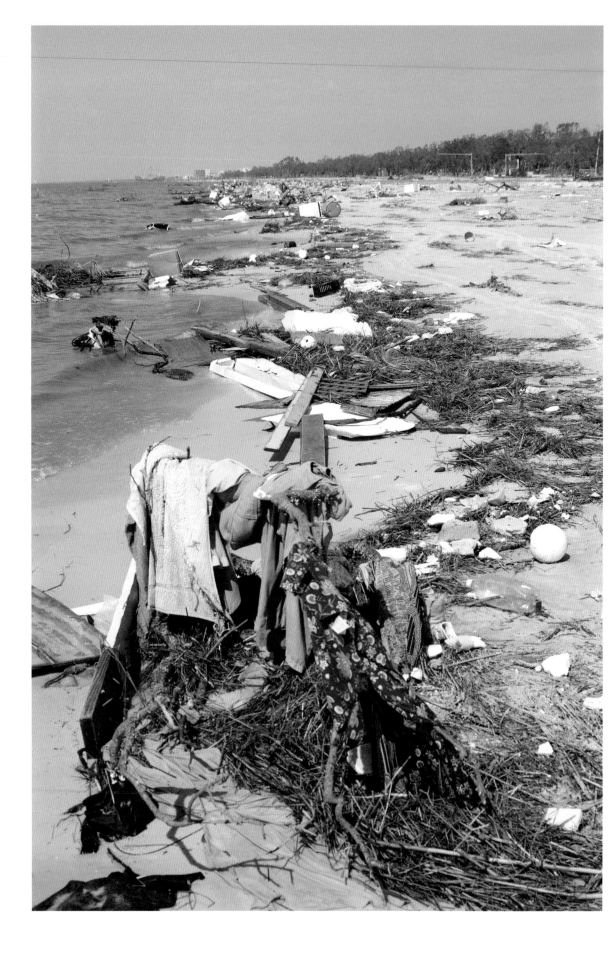

Biloxi Debris

(previous page) Debris of all kinds covers the beach near Biloxi. Although the contents included items of high value and cash, I avoided any temptation to take a single item out of respect for the victims and the desire to avoid any kind of bad karma from the storm Gods. So far, it's working.

Runaway Barge

(below) Several large barges broke lose during Katrina. Carried on storm surge waves, they became massive battering rams leveling and damaging buildings.

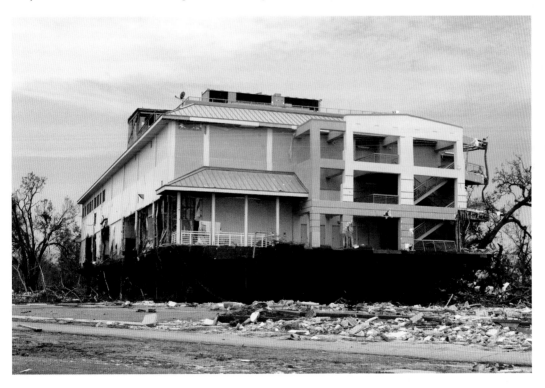

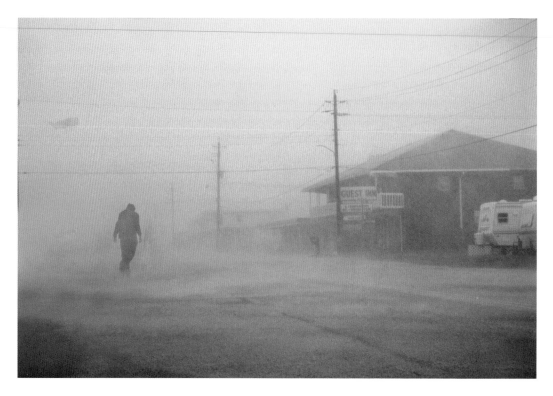

Debris Hazard

Flying debris is a constant threat while working in high winds. This lone figure was lucky, as I witnessed several pieces of debris fly over him during Hurricane Isabel in North Carolina. The secret to avoiding debris involves running from cover to cover between wind gusts—and a fair amount of luck. Falling debris is the most dangerous hazard, especially in urban areas with tall buildings.

Scouting Mission

I spend a lot of time scouting locations along the Gulf and Eastern U.S. coastlines preparing for hurricane strikes. I'm constantly in search of locations from which I can work—and survive. A good location must be able to survive a Category 5 storm with winds of 157mph or higher. I must also consider a 25-foot storm surge and have multiple escape routes.

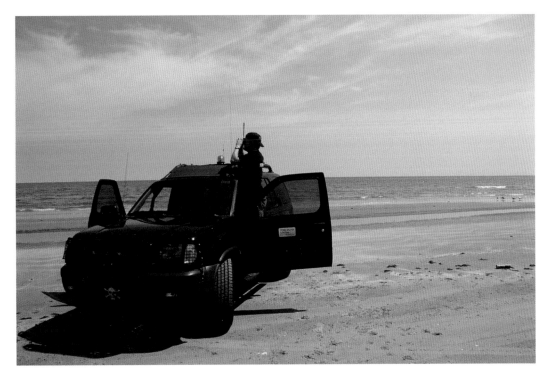

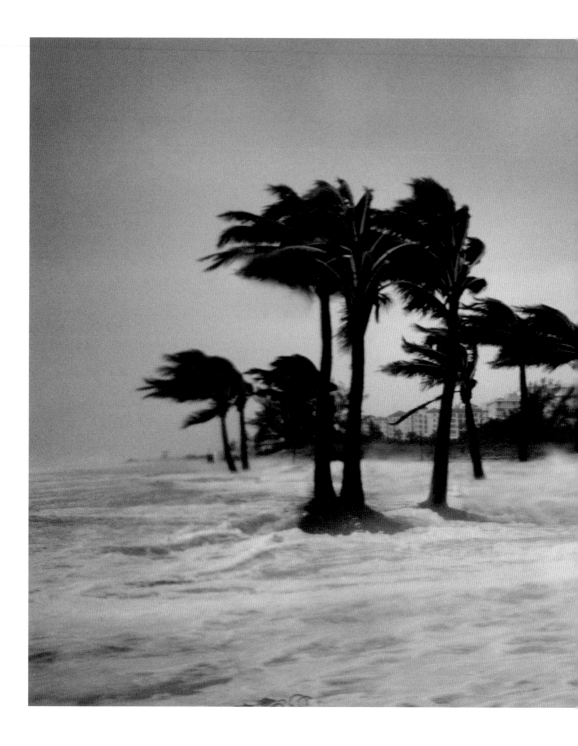

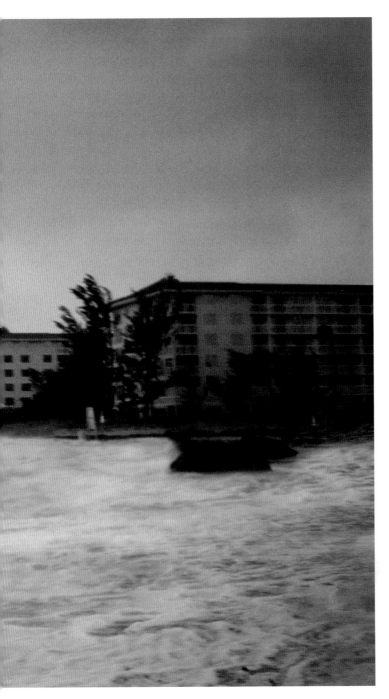

Near Tragedy

Another example of the perfect hurricane shot I'm always looking for. However, this one nearly came at a tragic price. Just after this frame was taken, a news crew covering me went too far out into the storm surge and narrowly made it back to shore. Although they were okay, their very expensive, professional HD camera was destroyed as huge waves engulfed them. Hurricane Frances, Juno Beach, FL.

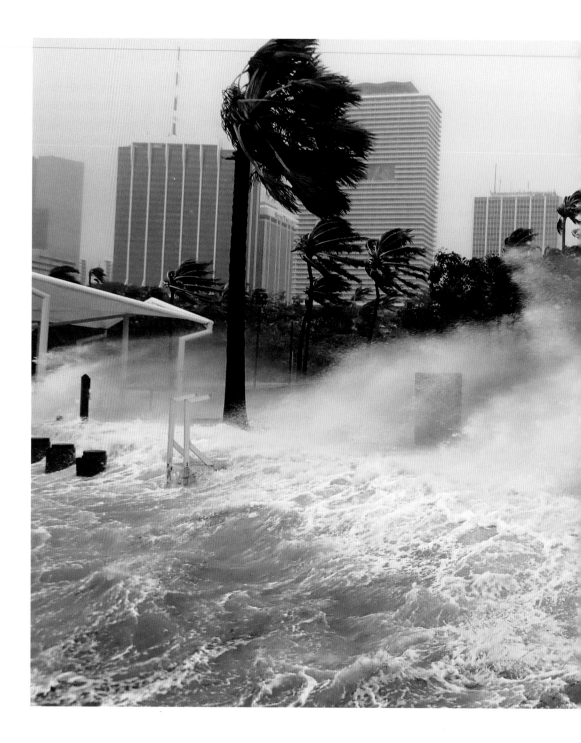

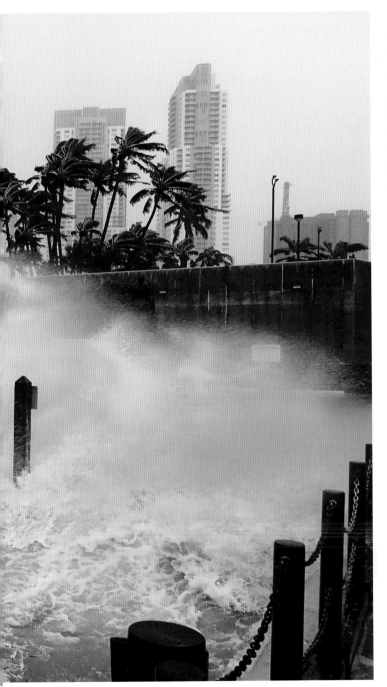

Irma

The 2017 hurricane season was one of the most active and destructive in U.S. history. I covered Hurricane Irma as it slammed into southern Florida with winds of over 100mph and a destructive storm surge. This image shows Miami, FL, taking a pounding.

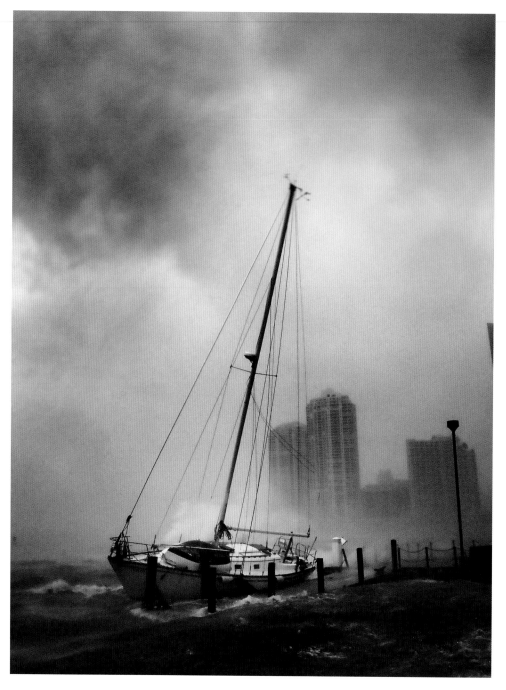

Abandoned Ship

I watched as this unoccupied sailboat was carried across Biscayne Bay by Hurricane Irma's storm surge. It only took a few minutes until the boat sank. I liked the black and white treatment, as it gave the image a dramatic look.

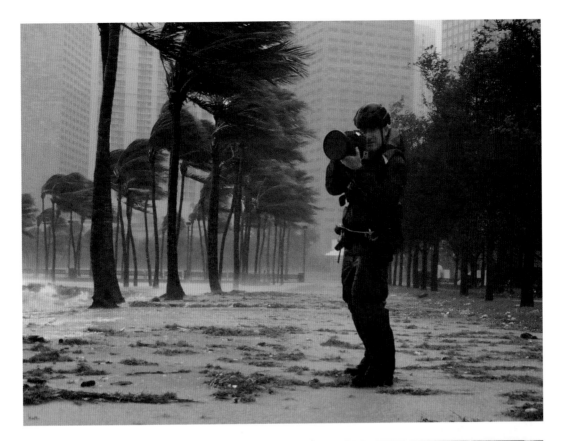

Storm Ready

(top) Mandatory hurricane chase equipment: helmet, waterproof cameras, raincoat, steel-bottom shoes, tripod, safety glasses, personal location beacon, inflatable life jacket, and an energy drink!

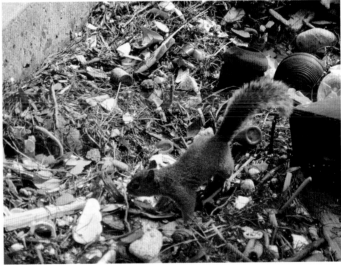

Finders Keepers

(bottom) This enterprising squirrel wasted no time sorting through piles of debris washed ashore during hurricane Irma in Miami.

Firestorm

I began my journalism career shooting fires. Like severe storms, fires offer a wide range of photographic opportunities, from close-up action to distant perspectives. This photograph was a last second frame as a massive firestorm raced toward me in northern Arizona. The heat became so intense, it singed the hair on my arms as I escaped to my vehicle and sped away. Rodeo–Chediski Fire, June 2002.

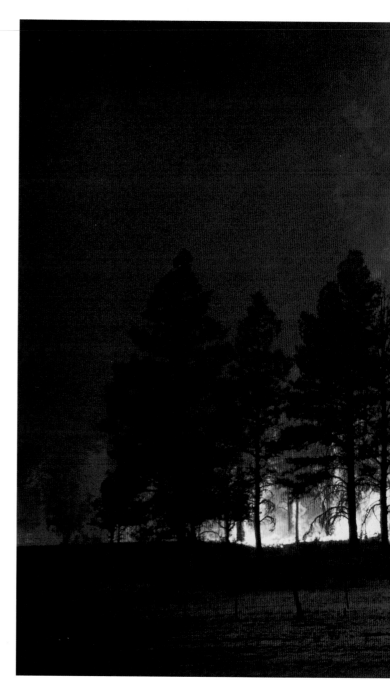

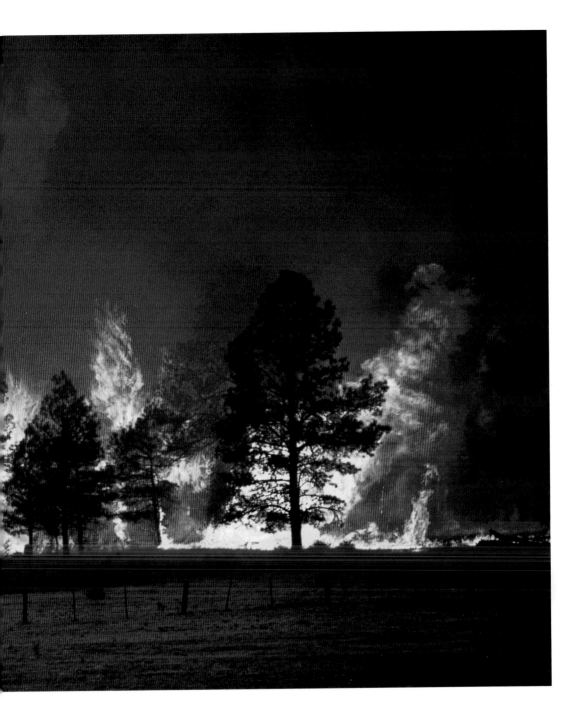

Fire Bomb

(below) Lightning strikes in the usually dry, desert southwest often spark wildfires. This wildfire near Oracle, AZ, was contained after low-level aircraft bombarded the flames.

Pyrocumulus

(following page) Some wildfires become so large they create their own weather systems, including downdrafts and updrafts. This massive fire in eastern Arizona produced a "pyrocumulus" cloud after extreme heat forced moisture and ash aloft.

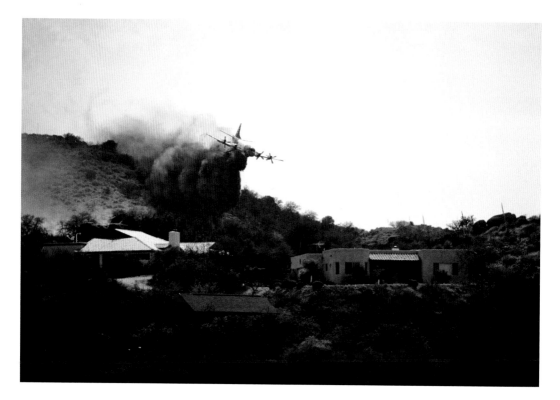

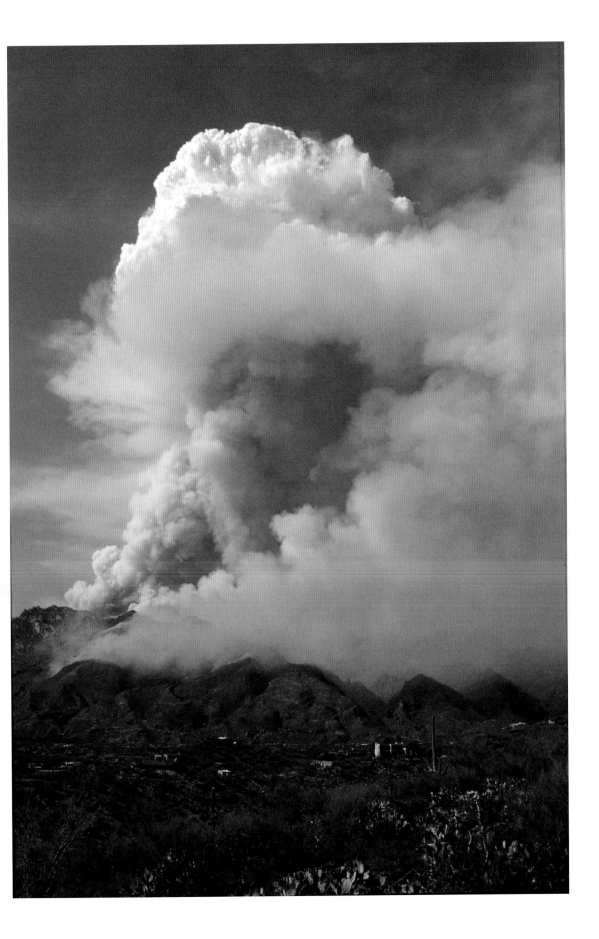

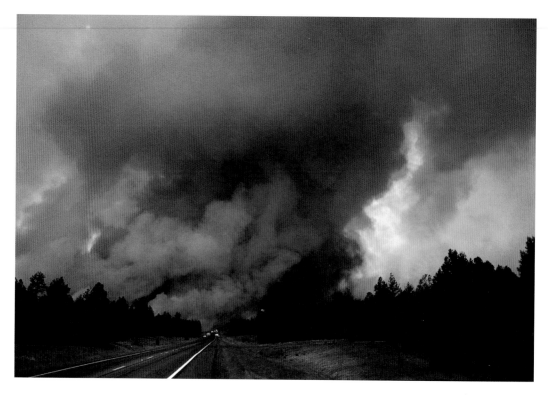

Road Block

(above) I have witnessed at least three firestorms during my career. This one crossed a northern Arizona highway after firefighters made a gallant effort to use the road as a fire break.

No Time to Waste

(following page) A fast-moving wildfire crests the foothills north of Tucson, AZ. This fire started after a lightning strike. I had to exit quickly because the fire began to move erratically as afternoon storms generated strong outflow winds.

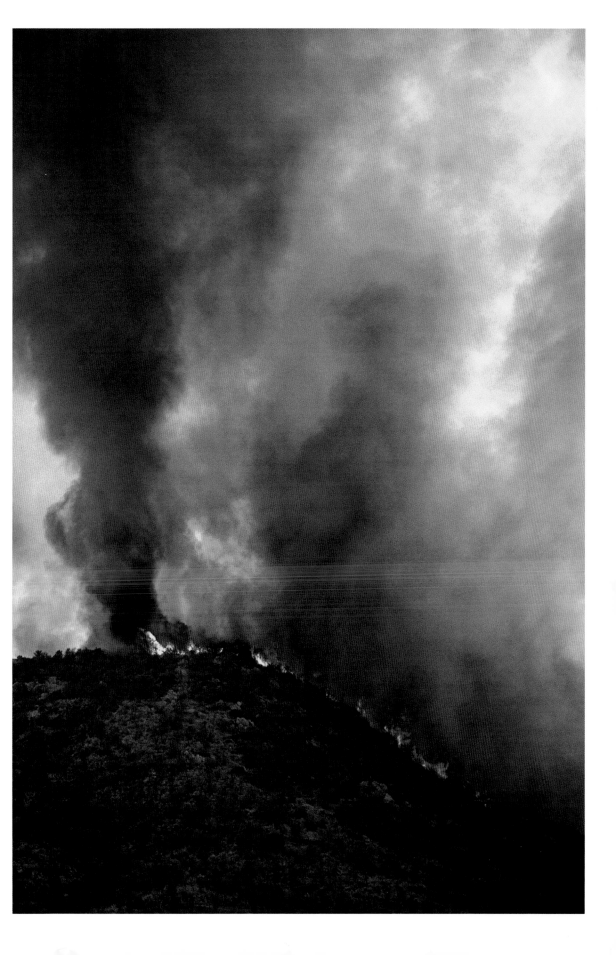

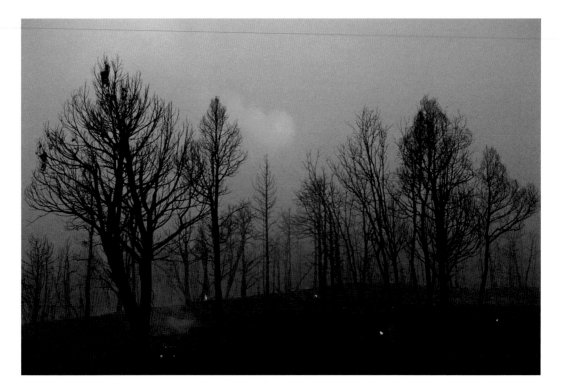

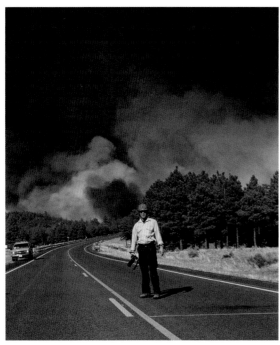

Necessary Destruction

(top) Naturally occurring wildfires are necessary to thin out old forest growth. In fact, some pine cones require fire in order to open seed pods and grow new trees.

Wildfire Education

(bottom) This fire was moving quickly toward my location but allowed just enough time for me to grab this self-portrait. Because I worked so much around fires, I achieved a Wildland Firefighter certificate. The information and experience have been critical for staying safe around fires.

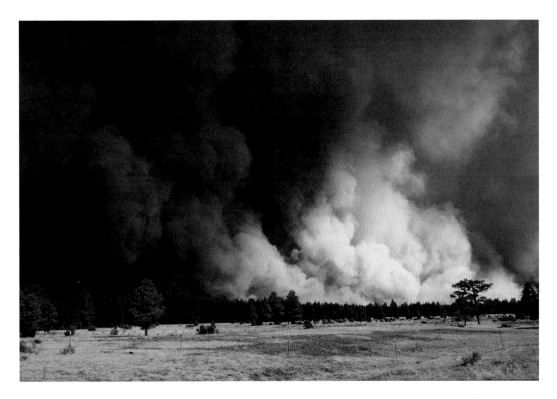

Ash and Heat

Heavy smoke rises above a massive wildfire in northern Arizona.

Wildfires are especially dangerous when high winds are involved. The most dreaded fire-related winds are the Santa Ana winds in California. Occurring mostly in the fall, Santa Ana winds can be sustained at over 40mph and gust to over 80mph, resulting in uncontrollable wildfires.

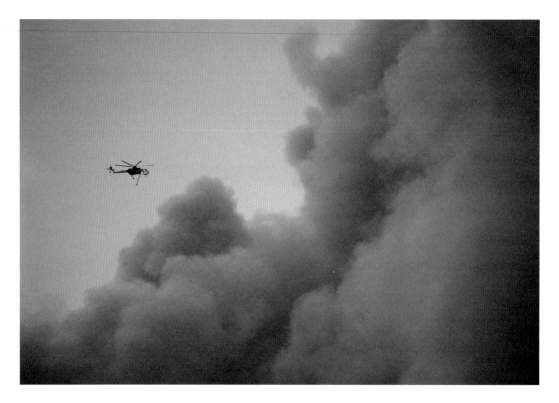

Water Drop

(above) Air operations are critical in saving lives and property. This sky crane flies near a billowing smoke cloud to drop a load of water on a fire in Oregon. The tanks on these helicopters can carry 2,500 gallons of water or fire retardant.

The Brave

(following page) Wildland firefighters make their way toward a wildfire near Sierra Vista, AZ. Fighting fires in the wilderness is hard and dangerous work. In June of 2013, a wildfire near Yarnell, AZ, overtook members of the Granite Mountain Hotshots, killing 19 firefighters. The fire images in this book are dedicated to their lives and memories.

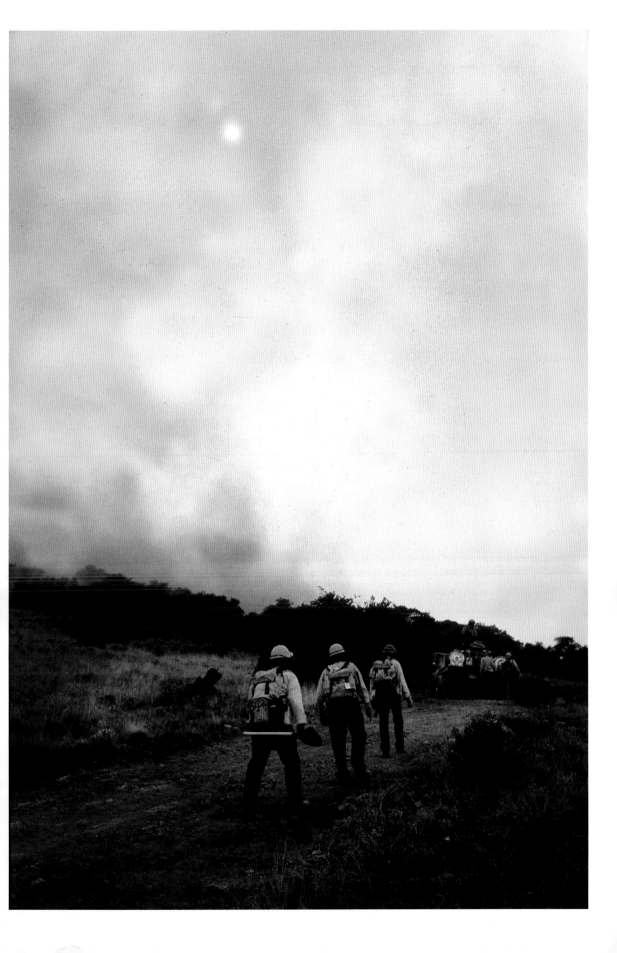

ICE, DUST and RAINBOWS

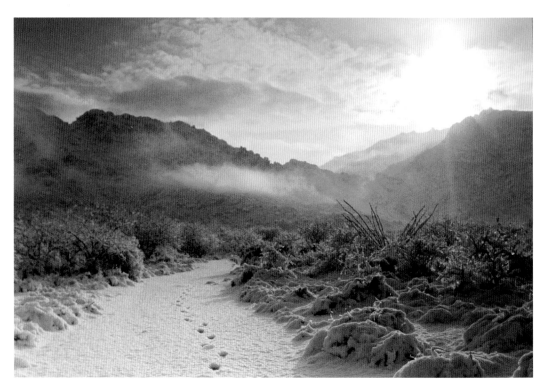

Cold Feet

Some of the best winter scenes are found in the morning after a light dusting of snow or ice. Sunrise light near Catalina State Park, AZ, provided a fine orange glow for this otherwise bland image.

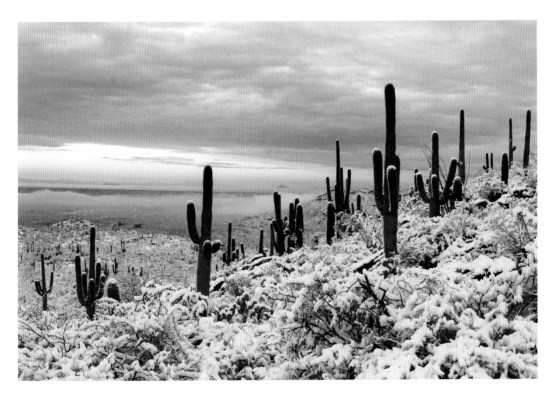

Desert Snowmen

It's rare to get more than a dusting of snow in the Sonoran desert, but when it happens, you can expect every respectable photographer to be out at dawn. This image was captured from the eastern foothills of Tucson, AZ.

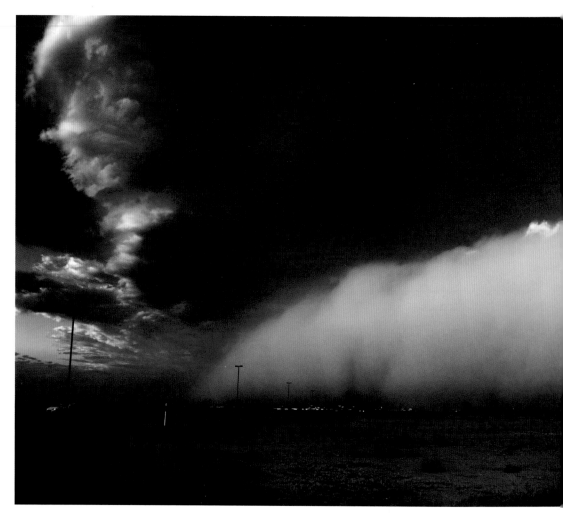

Haboob

Dust storms are a dangerous reality of thunderstorms. Driven by storm outflows, dust storms can create zero visibility along highways, causing deadly accidents. This large dust storm swooped across Phoenix, AZ, in July of 2014. In the desert southwest, dust storms are also known as "haboobs," an Arabic word for blowing dust.

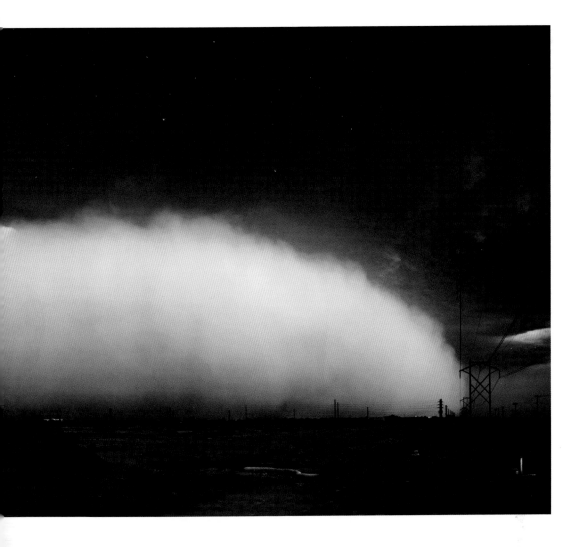

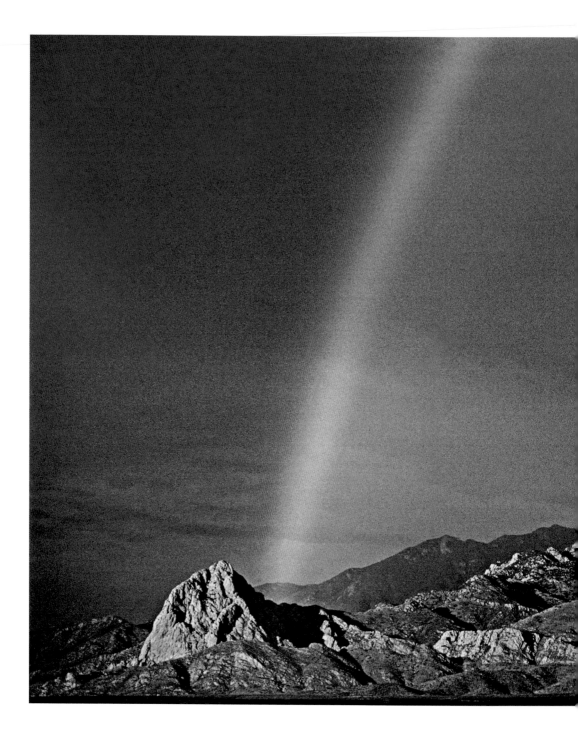

Nature's Irony

I have seen many rainbows following violent storms and disasters. It's the ultimate irony. It seems as if mother nature is telling us that despite her dark side, there is always hope. Likewise, I figure a few rainbow pictures would be a fitting way to end my book.

This rainbow appeared near Elephant Head rock in the Santa Rita Mountains south of Tucson.

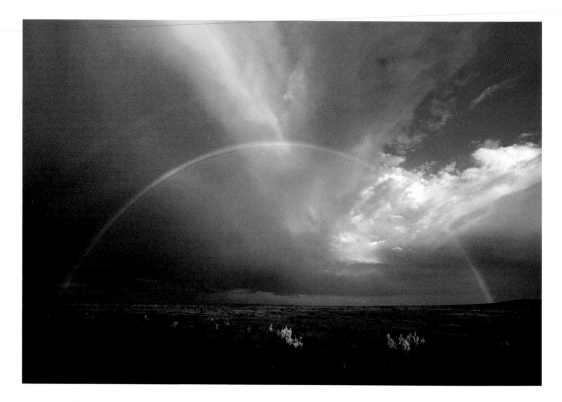

Desert Prism

(above) A full rainbow in eastern New Mexico. I often use a polarizing filter set to the minimum effect when shooting rainbows. This helps to reduce unwanted glare and provides contrast.

Pot of Gold

(following page) This is one of the most intense rainbows I have ever photographed. All colors of the rainbow spectrum can be seen. It developed after a passing storm near Lamar, CO.

May a pot of gold be found at the end of your dreams.

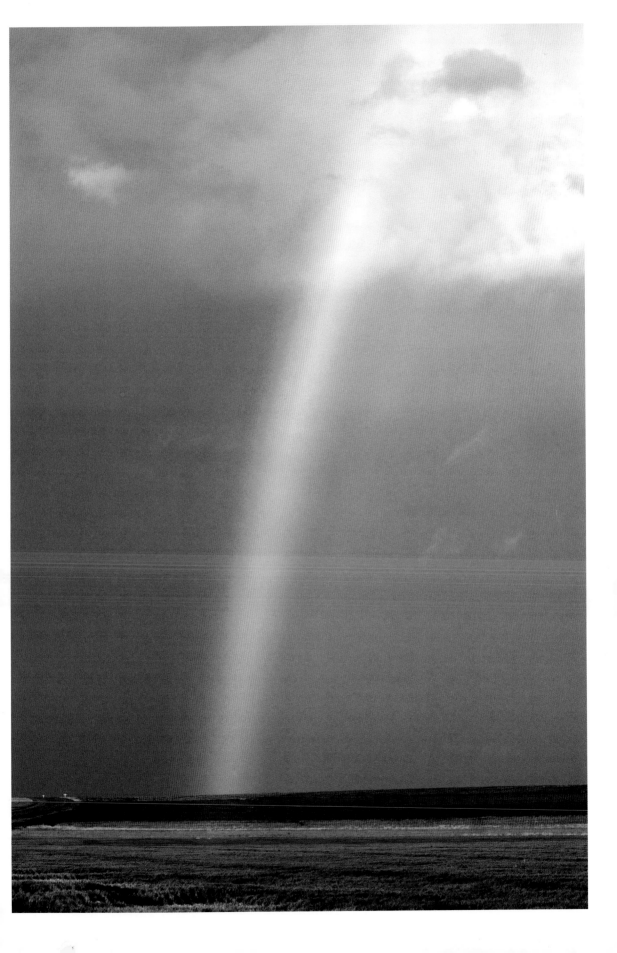

INDEX